HEX SIGNS

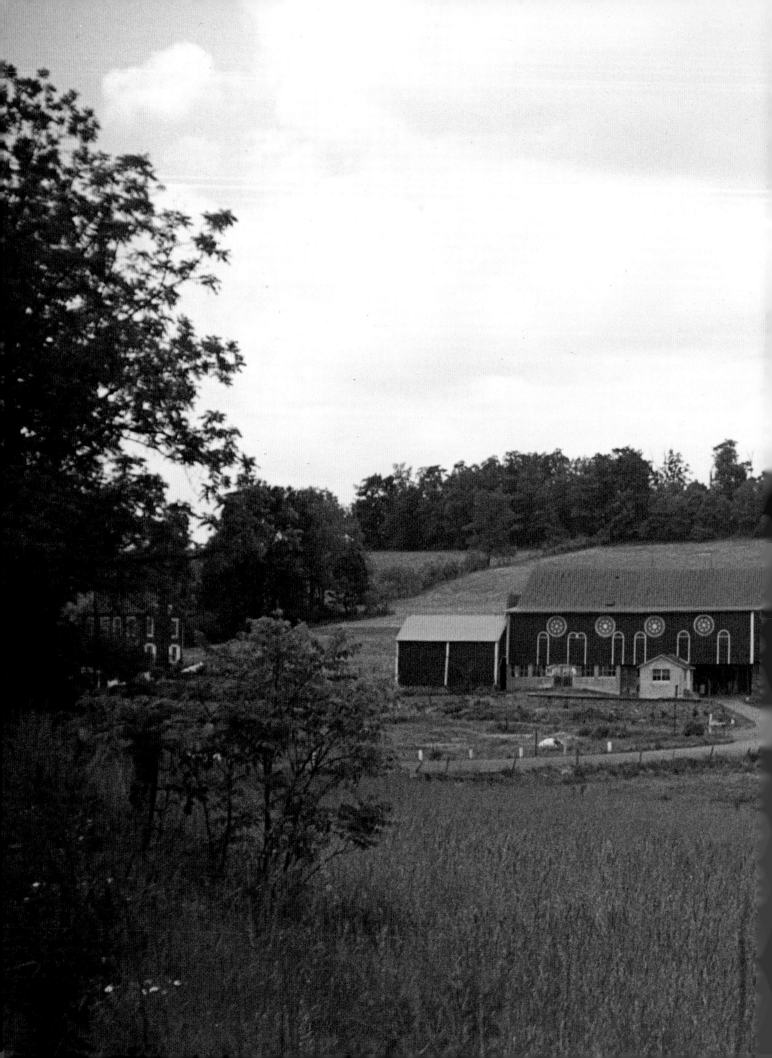

HEX SIGNS

Pennsylvania Dutch Barn Symbols and their Meaning

Don Yoder and Thomas E. Graves

Introduction by Alistair Cooke

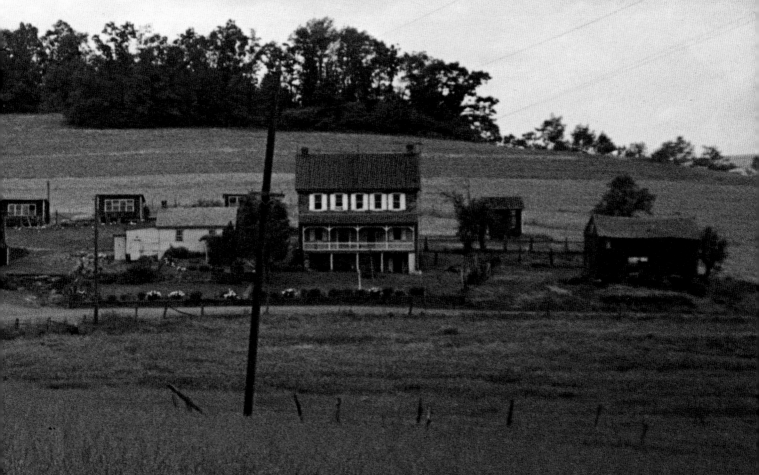

E. P. DUTTON · NEW YORK

In association with the
MUSEUM OF AMERICAN FOLK ART · NEW YORK
and
Arts International Program / Institute of International Education · New York

1. The typical Berks County farmstead (near Virginville) illustrated on the two previous pages shows the order and balance achieved through the placement of the buildings as well as the visual relationships between the barn's hex signs and painted arches and the windows and porch patterns of the farmhouse. This sense of order stems from a folk aesthetic shared by the Pennsylvania Germans of the region. (Photograph by Don Yoder)

All photographs and drawings are by Thomas E. Graves, unless otherwise noted.

DON YODER is Professor of Folklife Studies at the University of Pennsylvania, where he has taught since 1956. A native Pennsylvanian, he has pioneered in the study of American regional and ethnic cultures and their backgrounds abroad. He was a founder and longtime editor of *Pennsylvania Folklife*, and has served on the editorial boards of the *Winterthur Portfolio* and the *Yearbook of German-American Studies*. He has been Winterthur Fellow and President of the American Folklore Society. His latest book in the folk-culture field is *American Folklife* (1976), his latest in the Pennsylvania German field are *Pennsylvania German Immigrants, 1709–1786* (1980), and *Rhineland Emigrants* (1982).

THOMAS E. GRAVES has a doctorate in folklore and folklife from the University of Pennsylvania. He has been studying and photographing the culture of the Pennsylvania Germans for more than a decade. Dr. Graves's dissertation, *The Pennsylvania German Hex Sign: A Study in Folk Process*, remains the most detailed study of the hex-sign phenomenon. He has published articles on Pennsylvania German gravestones, the contemporary crafts movement, Native American crafts, and Gypsy culture. He has encouraged national interest in these topics through his editorial duties for the Pennsylvania Folklore Society and the Middle Atlantic Folklife Association and through his participation in the American Folklore Society. Dr. Graves has taught at The Pennsylvania State University and at Ursinus College.

The two-stanza poem beginning "So blue my hills, so misty blue...," which appears on page 35 of this book, is reprinted from *Blue Hills and Shoofly Pie* (1952) by Ann Hark by kind permission of Harper & Row Publishers, Inc., New York.

Book design by Nancy Danahy
Copyright © 1989 by Don Yoder and Thomas E. Graves.
Published in the United States by E. P. Dutton, a division of NAL Penguin Inc., 2 Park Avenue, New York, N.Y. 10016. Published simultaneously in Canada by Fitzhenry and Whiteside Limited, Toronto.
Library of Congress Catalog Card Number: 88-51704.
Printed and bound by Dai Nippon Printing Co., Ltd., Tokyo, Japan.
ISBN: 0-525-24466-2 (cloth); ISBN: 0-525-48262-8 (DP).
10 9 8 7 6 5 4 3 2 1 First Edition

INTRODUCTION

ENCOUNTERING THE HEX
By Alistair Cooke

The first I ever heard of hex signs was from an old Quaker lady in Radnor, Pennsylvania. She tantalized my curiosity by speaking darkly of the Pennsylvania Dutch and their heretical devotion to witches and the symbols used on barns to exorcise them. As a young journalist, only lately arrived as a correspondent for the London *Times* and the BBC, I was hot to track down the more bizarre bits of Americana, especially those that might rouse the British reader from his firm belief that the landscape of the United States, where not choked by billboards, was an alternating stretch of forests and deserts inhabited in the East by prim Puritans, in the West by Indians (and the descendants of the Sydney convicts in San Francisco), and throughout the Middle West by the more crass characters out of Sinclair Lewis.

By that time, 1937, I had already done two automobile tours of the United States during the years of my graduate fellowship at Yale and Harvard, and I had seen enough of the dramatic variety both of the landscape and its people to convince me that there was a long and useful career awaiting an energetic reporter who would dedicate himself simply to puncturing the British preconceptions. In the spring of 1937, then, I set out to investigate for myself some of the exotic places and people I had heard about. High on my agenda were the ghost towns of Nevada; the weird Spanish-Irish dialect spoken by the Basque sheepherders of Idaho; and the alleged mock-crucifixion of a young man on Good Friday by the Penitent Brothers, an irregular Catholic sect that was said to practice its barbarous annual rite in the mountain fastnesses of New Mexico (I was there at dawn and hung around through the day but they failed to show up).

By contrast, the decorations that farmers chose to inscribe on their barns might have seemed very small potatoes indeed, had not the lady from Radnor assured me that witches were rampant, even airborne, among the Dutch (she was old enough to insist on "Deutsch"),

and that only recently there had been at least one murder by or against some "Hex-woman" in York County. I must say that my early, and excited, passage through Pennsylvania on my way West was a letdown, from the point of view of a seeker after voodoo. I was cheered by an evening meal of the renowned seven sweets and sours. It was prepared by a family of Lutheran farmers who had hex signs on their barns all right, but were no more disposed to talk about evil spirits or local witches than they would, in those days, have initiated a conversation about cancer. The effect of this tight-lipped taboo was not to dampen my curiosity but to arouse it, as a well-bred family observing a strict silence about its one black sheep would make him the only one you wanted to know about. I believed all the more in the likelihood of the York County murder. But on my way out of Pennsylvania, I was told by various people that the charming hex signs had, indeed, no other function than to ward off sickness, poor crops, and vengeful neighbors. However, on a later trip, the sinister legend was taken up and reinforced by no less an authority than the Federal guide to Pennsylvania, in the splendid series of state guides compiled by the writers of the Works Progress Administration—the WPA—one of the many so-called alphabet agencies set up by the Roosevelt administration to relieve the huge unemployment during the Depression years. In that guide it is stated that near Riegelsville a region alongside the Delaware Division Canal is called Hexicopf (German for "witch head") and that it once "contained a jasper mine of religious significance to the Indians (but) rather than have its secret known, they abandoned the mine when white settlers arrived. For some reason, the German settlers later fixed it as the scene of witches' revels." The guide goes further. In its chapter on "Ethnic Groups and their Folkways," it asserts that neither "Powwow" doctors nor witches have wholly disappeared, and that "within the past decade" (this was the

1940 edition) "there have been cases of murders directly traceable to Hexerei." I had no time to do much tracing, either direct or indirect, and never thereafter met anyone who could substantiate this lurid story.

Some years later, in the middle or late 1940s I should now guess, a canning company had the bright idea of printing, as advertisements, full-color reproductions of the more decorative hex signs. For the first time, I was impressed more by their variety and beauty as ornamental designs. Their iconography appeared to me to be too complex, if not sophisticated, to be the simple expression of a primitive superstition. But, obviously, a good many other American matters called for the attention of a reporter who had by now become the chief American correspondent of the Manchester *Guardian*.

I let the hexes go and gave them no more thought until three years ago, when I became chairman of Arts International, which has attempted to set up the first center for international exchange in the arts, whereby private corporations would be encouraged to sponsor in their own country arts native to another country. My own ambition was to extend the definition of "the arts" beyond the usual roster of opera companies, dancers, painters, musicians, and so on. I suggested that an exhibition of the military drawings of Leonardo da Vinci might be equally appealing to New Yorkers as to Romans; that Madrid might be encouraged to import an exhibition of the branding signs of the American Southwest as a neglected legacy that the Spanish left to this country; and that the Germans, as also the Americans, might entertain the idea of a showing of Pennsylvania hex signs. It was then that Dr. Robert Bishop told us of his plan to publish, under the auspices of the Museum of American Folk Art in New York City, a new and authoritative study of the Pennsylvania hex signs.

And here it is: a work of careful and blessedly sensible scholarship, giving the witness stand impartially to theories plausible, ingenious, or wild; having no ax to grind; disposing with impressive finality of the shibboleths of murder and exorcism, yet sorrowfully conceding that the tourist will always keep alive the most sinister or sentimental interpretation of an historical event, especially if it is complex. So here, at last, Dr. Don Yoder and Dr. Thomas Graves have given us an account that opens up inquiry rather than suppresses it and leaves us in the end with a fascinating American mystery.

THE WORLD OF THE HEX SIGN

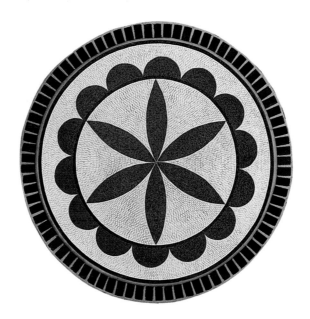

Hex signs and the barns on which they appear are an integral part of the American culture developed by the Pennsylvania Dutch or Pennsylvania Germans (these names are interchangeable). As pioneer settlers in much of southeastern Pennsylvania, this Colonial ethnic group evolved into one of the most colorful and most original cultures on the east coast of the United States.

The emigrants came here in the seventeenth, eighteenth, and early nineteenth centuries, up to the period of the Napoleonic wars, from the German-speaking areas of central Europe—Germany, Switzerland, Alsace-Lorraine—and the old Austrian Empire. They were a mixed group, both ethnically and culturally, and when they settled together in Pennsylvania, they not only shared their varied cultural baggage with each other, but they borrowed other cultural elements from their neighbors in Penn's Woods. These included the Delaware Indians, the English Quakers, the Scotch-Irish, the Welsh; and the Blacks (many of whom learned to speak Pennsylvania Dutch). Even the Jewish peddlers who circulated through upstate Pennsylvania adjusted their Yiddish to Pennsylvania German for their clients and friends.

In America, the Pennsylvania Dutch, with their diverse European backgrounds, formed one people with a culture united except for religion. On this point, they were divided into majority and minority factions, or as sociologists put it, into "churches" (groups which accept the world and its culture) and "sects" (groups which disapprove of "worldly" trends and attempt to live austere lives away from temptation). The church groups were in the majority and they included the Lutherans and the Reformed, denominations that were the American offspring of the German and Swiss reformations of the sixteenth century. The sectarian groups, now also denominations in the American terminology, were the offspring of the Anabaptist and Pietist movements in the sixteenth and seventeenth centuries. They included the Mennonites, Amish, Brethren, Moravians, and various communitarian groups such as the Ephrata Society and the Harmonites. The sects were often called the "Plain People" or the "Plain Dutch" because of their insistence on simplicity or plainness in dress, speech, and manner of life, although there was variation between the groups, some being plainer than others. This religious cleavage goes far to explain why hex signs are not found everywhere in southeastern Pennsylvania. For example, they are common in Berks County, a typically Lutheran and Reformed area, but largely absent in Lancaster County, where the "plain" groups shaped the dominant culture.

What Are Hex Signs?

We will call them "hex signs" because that is how they are known to the rest of the nation who come as tourists each year by the hundreds of thousands to visit the Dutch Country. Hex signs are geometrical decorations in the form of large stars of various formats painted on the facades or gable ends of Pennsylvania barns. The word "hex" is the German word for "witch." According to journalists and purveyors of tourist literature from early in the 1920s, these decorations were placed on barns to ward off evil influences from neighboring witches or even the Devil. This, of course, is only one theory about the origin of the signs. The point of our exhibition and book is to investigate the possible meanings these decorations may have, both historically and at the present. Our evidence is drawn from the motifs themselves, their origins in the Old World, and their evolution in Pennsylvania.

In short, two levels of the hex-sign phenomenon confront us. First is the historical practice of painting hex signs on barns. These signs were created using the traditional vocabulary of Pennsylvania Dutch folk art, and, in fact, represent its last flowering in that the hex sign transfers traditional design motifs from the decorated object to the decorated barn. The second phenomenon, of more recent date, is the hex-sign myth, the popular spinoff of tourist literature *about* the hex signs, with the development of new types of hex signs and the attribution of meanings to each symbol. While the tradition of painting barns with hex signs began in the nineteenth century, in the 1860s or before, and has lasted to the present time, the mythology about the meaning of the signs has its roots in the 1920s.

At that time, two events focused public attention on the witchcraft beliefs of the Pennsylvania Dutch. First, Wallace Nutting (1861–1941), in his book *Pennsylvania Beautiful* (1924), raised the claim that the barn signs were put there to ward off evil. Nutting referred to the barn signs as "Hexafoos" (meaning witch foot). Secondly, a witchcraft-related murder in York County, Pennsylvania, in 1929 gripped the attention of the news media and introduced the words "hex" (witch), "hexerei" (witchcraft), and "ferhext" (bewitched) into the contemporary American vocabulary. A logical fusion of these two events resulted in the term *hex sign*, which first appeared in print in the mid-1930s. This coinage, with its powerful mingling of symbols, led in turn to the contemporary expansion of Pennsylvania German folk art.

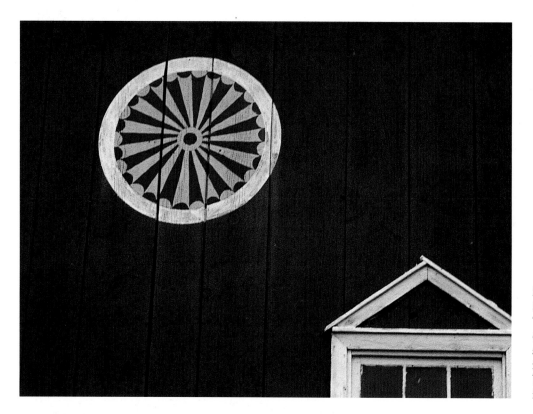

2. Wheel-of-Fortune (near Shanesville, Berks County). Thirty spokes with a central dot. The border has internal scalloping like that on the barn in figure 58, but has a thick border instead of the triangles found on that barn.

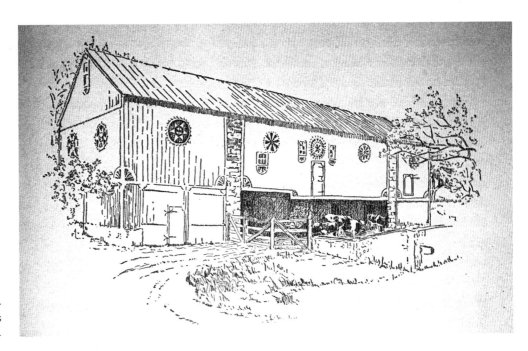

3. A "witch-foot" barn illustrated in Wallace Nutting's *Pennsylvania Beautiful* (1924).

The Historical Hex Sign as Folk Art

It was in the realm of folk art that the Pennsylvania Germans showed great originality. Taking a body of symbols and motifs with which their forefathers had been acquainted in Europe, they decorated everything within range. Pennsylvania Dutch furniture—the great *Schranks* (wardrobes), the dower chests, the painted clocks, chests of drawers, and all the rest—has achieved national attention in our century. Their fraktur documents or "manuscript art" have likewise come into national prominence with representative pieces to be found in major museums and in innumerable private collections. Pennsylvania rifles, pottery with its German inscriptions, the samplers and show towels, the pie safes, and even such noncollectibles as tombstones—all were part of the eighteenth- and nineteenth-century flowering of Pennsylvania Dutch folk arts. Produced by competent craftsmen, these pieces combined both utility and unusual beauty.

The motifs used on all these items included, among others, the geometrical designs that we now refer to as hex signs. Six-point and Eight-point Stars, Whirling or Swirling Swastikas, Wheels-of-Fortune, and other circular motifs were first applied to household objects,

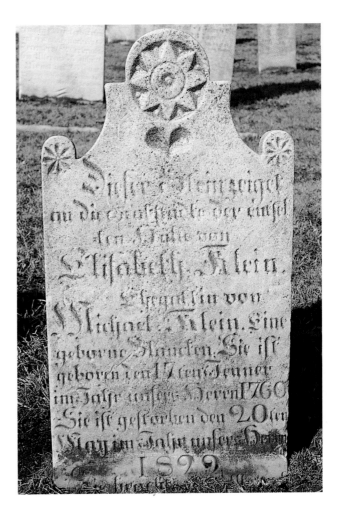

4. Hex-sign motifs on a Pennsylvania German tombstone (dated 1822) from the Berks-Lehigh border region.

3

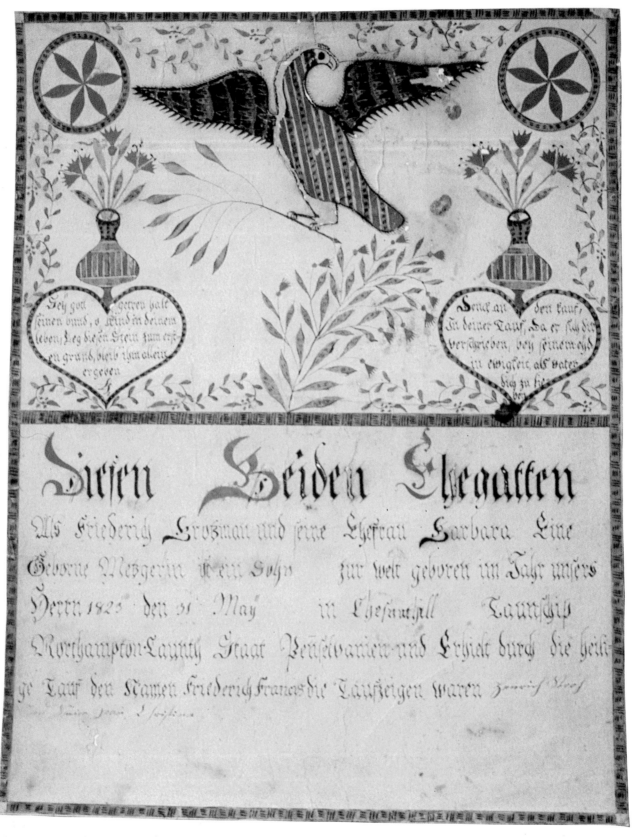

5. This combination of Pennsylvania German, patriotic, and Victorian designs illustrates the widening of the motif vocabularies among the Pennsylvania Dutch in the first quarter of the nineteenth century. (Courtesy Historical Society of Pennsylvania; photograph by Don Yoder)

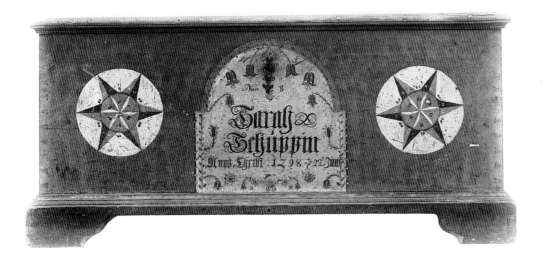

6. Chest dated 1798. The decoration includes the symmetrical placement of geometrical designs with the arch and rectangle later found on barn facades. (Courtesy Philadelphia Museum of Art)

furniture, fraktur, and tombstones. Here, because of their small size, the designs were restricted and intimate—often, on fraktur and pottery especially, mingling with other motifs to make overall patterns fit the limited space.

At some point toward the middle of the nineteenth century, an innovative folk artist in the Dutch Country performed the final creative step in the evolution of the hex sign by transferring the old geometrical patterns, in enlarged format, to the exteriors of the barns. The scale of the art was no longer intimate or personal, as with an individual studying his *taufschein* (baptismal certificate), or a family group enjoying the color and shape of a painted chest in the *stube* (stove room). Now the designs became public and impersonal, facing the carriage and wagon roads for all the world to see and admire.

Circles, Stars, and the Metaphysical

When we survey the world of art, we find that the geometrical designs used in hex signs—stars within circles, and various patterns of stars—have been practically universal from ancient Sumeria to the present. This is not to say that they have been found absolutely everywhere, in all periods, or in all forms of artistic expression, or even that the Pennsylvania German motifs are the direct descendants of the Sumerian ones. But everywhere that man has transferred celestial images to expressions of art, these geometric motifs have appeared.

Geometrical designs, especially circles, stars, and related patterns, were once, and perhaps still are, part of the "polite" level of artistic expression in many societies, as opposed to folk art. For example, in the

7. Austrian chest (1891) decorated with Rosette and Whirling Wheel-of-Fortune. The design around the Rosette is called Running Hound. (From Reinhard Peesch: *Ornament der Volkskunst in Europa*, Leipzig: Edition Leipzig, 1981)

Middle Ages they appear in stone and glass in architecture—rose windows and clerestory balustrades with stone stars and swastikas. Even the bishop, who was one of the architects of the cathedral of Speyer, was buried in a stone tomb that is literally covered with geometrical hex signs, some of which certainly suggest a connection with later Pennsylvania German motifs.

When European art flowered into representational art—into pictures with depth, mass, and perspective—and went its own higher way during the Renaissance, abstract and geometrical art of the Middle Ages survived on the folk level. Rural artists and craftsmen retained the old designs, a process that often happens in peasant societies when the outside world moves on to new fashions. Craftsmen put these geometric designs on everyday objects, on furniture and tools. Women worked them into woven cloth, embroidered them onto samplers and show towels, and eventually pieced them into quilts.

One has only to leaf through recent studies of European folk art, from the Balkans to the British Isles, from the Mediterranean shores to Scandinavia, to see that our geometrical designs were, in the "classical" folk arts of the past three centuries, universal across the map of Europe. They stare at us from nearly every object in the peasant home, and in some areas were even put on the house itself.

This universality of the designs has led European scholars to debate their origins, diffusion, and meaning. One school of thinking drew its interpretation from the mythological orientation of the Grimm brothers (the same brothers widely known for their fairy tales) and other scholars of the Romantic Period. These scholars viewed the geometrical patterns on folk objects as ancient symbols of magical and protective power, with deep roots in the pre-Christian religions of Europe's past. To this school of thought, any circular design was a "sun wheel," from the prehistoric worship of the life-giving powers of nature. The swastika—an almost universal symbol from Orient to Occident—meant life and good fortune, the four directions, the four seasons, and—again the sun cult—the movement of the sun through the seasons.

After the close of the nineteenth century, an opposing school of thought developed. This school took the practical view that geometrical designs were simply pleasing patterns, easy to draw or carve or paint, the underlying purpose of which had nothing at all to do with magic. Rather, they were viewed as springing from a "folk aesthetic," providing space fillers, so to speak, to avoid the blank spaces that folk artists the world over appear to abhor. These designs, furthermore, were seen to grow out of the techniques of working certain media, as for example the chip-and-

8. Lavish use of hex-sign motifs on the exterior of a 1601 miner's inn, later used as a barn. Grunau (Gronow) County of Hirschberg (Jelenia Gora), Lower Silesia, Poland. The designs were done in reds and browns, and there are alternating positive and negative forms of the Rosette. (From Ludwig Loewe: *Schlesische Holzbauten*, Düsseldorf: Werner-Verlag, 1969)

scratch carving on soft wood, which lends itself to geometrical motifs.

This European controversy over the meaning of the ancient symbolism had developed into opposing camps by the time Americans began in the 1920s to explore the hex sign and its meaning. European arguments contributed to thinking here, as many Pennsylvanians were well aware of the European research. Pennsylvanians, like the Europeans, have asked the same question: Are geometrical designs applied to folk objects simply pleasing, practical ways of filling up space, or are they (originally or now) symbols of magical and protective powers? There is no firm answer.

In addition, there is one final question that should be asked in relation to European backgrounds of Pennsylvania German hex signs: Were they applied in Europe to the exteriors of buildings in the same spectacular manner as in America? Here the answer is negative, or at least, negative with certain qualifications. Stars, circles, and related geometrical patternings did appear on the exteriors of European buildings, often above or on the sides of gates, doorways, windows, or sometimes on the facades of houses or small outbuildings.

Among those regions in Europe from which Pennsylvania German culture derives, several stand out as possibilities for comparative study. Westphalia and Hessia, in central or north-central Germany, are two regions where similar geometric designs appear on the half timbering on the facades of houses. Switzerland is another important region where houses are decorated with geometrical motifs. Switzerland sent major streams of emigrants to Pennsylvania before the nineteenth century. Two parts of Switzerland can be singled out in particular. Canton Graubünden in southwest Switzerland, bordering on Italy, features many huge stone houses with facades decorated with geometrical designs similar to our hex signs. Houses in parts of Canton Bern show the same designs applied to the generally unpainted gables. Sometimes they even appear on the underside of massive overhanging eaves, so that when looking up one sees stars looking down!

9. A barn entryway illustrated in Wallace Nutting's *Pennsylvania Beautiful*.

In general it can be said that the Swiss designs do not have the same visual impact as the hex signs in Pennsylvania, as they are usually placed in competition with other motifs, with decorative borders, and often with lengthy religious inscriptions. Hence Pennsylvania's hex signs are the result of cultural innovation, brought about when some unknown Pennsylvanian decided to isolate the geometrical designs and apply them in large format to the facade and gable end of his barn.

The Scholars' War

Just what are the hex signs supposed to mean, if they have any meaning at all? This question lifts the lid on an acrimonious and ongoing controversy in the world of Pennsylvania German scholarship. At the heart of this controversy lies the fragmented character of Pennsylvania Dutch culture itself. It has become a culture divided into radically opposing camps.

While the outside world has been aware of hex signs through fiction and magazine illustrations since the

turn of the century, the year 1924 marks the beginnings of the scholarly hex-sign controversy. Illustrations of hex-sign barns appeared in the October 1924 *Journal of the American Institute of Architects* in an article by C.H. Whitaker, who described them as "ornaments with sun bursts in yellow or with other curious designs, some said to be symbolic and also said not to be." Whitaker was quoted as saying: "Some day I may be persuaded to find out just what these curious decorations mean." We regret to report that he never continued his search.

It was Wallace Nutting's *Pennsylvania Beautiful*, which also appeared in 1924, that lit the fires of controversy.

> The ornaments on barns found in Pennsylvania, and to some extent in West Jersey, go by the local name of hexafoos or witch foot...They are supposed to be a continuance of very ancient traditions, according to which these decorative marks were potent to protect the barn, or more particularly the cattle, from the influence of witches...The hexafoos was added to its decoration as a kind of spiritual or demoniac lightning-rod.

Nutting claimed to have gotten this interpretation from a single informant—a dangerous practice in fieldwork—who convinced him that the emigrants had brought the practice from their European homelands.

Nutting's statement and his term *hexafoos* were widely copied in other treatments of the Pennsylvania Dutch and have been the major contributor to the tourist literature focusing on the supposed apotropaic or evil-deflecting purpose of the barn decorations.

The leading scholarly apologist for the magical and apotropaic interpretation of the hex signs was Dr. August C. Mahr (1886–1970), a professor at Ohio State University, himself of German birth. In several articles that appeared both in Germany and in the United States in the 1950s, one of which achieved canonization of sorts by its inclusion in a major introductory text in American folklore, Professor Mahr held the line that the signs not only had meaning, but they were indeed "hex signs," looked upon by their painters and possessors as having magical protective powers. His work was comparative, citing examples of the use of these motifs from various parts of Europe. He drew some interesting conclusions. Faced with the fact that in Europe the signs are not usually found on building facades except in places like Canton Bern in Switzerland, he developed the theory that the Swiss emigrant among the Pennsylvania Dutch, in shifting from his usual wooden house facade to a stone structure in Pennsylvania, transferred the geometrical signs that in Switzerland appeared on the front of his house to his wooden barn facade.

It was Mahr's opinion that the Pennsylvania Germans preserved and used the hex signs here because their forefathers had used them in Europe. They were part of the traditional community culture of the Rhineland villages, and the Pennsylvania Germans continued to use them here because they preserved more of the European traditional sense of community than did their ethnic neighbors. What he concluded was that the average Pennsylvania Dutchman wanted hex signs on his barn because it was part of his "group psychology" to need them. To the outsider he will probably deny

10. *Hex, No!* With this booklet, published in 1953, Dr. Alfred L. Shoemaker made it clear which side of the controversy he was on—namely, that hex signs have no magical significance.

that they are hex signs, while he continues secretly to believe in their efficacy—an attribution of double standardism to the Dutch for which the professor has often been criticized. Yet Mahr's thesis is a thoughtful one and, right or wrong, he stirred up a great deal of attention.

The direct opposite of the apotropaic theory is that the hex signs have no hidden or occult meanings at all, but are plain ordinary decorations. The principal spokesman for the decorative theory was Dr. Alfred L. Shoemaker (b. 1913), who aired his ideas in his popular pamphlets, *Hex, No!* (1953) and *Three Myths About the Pennsylvania Dutch Country* (1951), as well as in his scholarly volume *The Pennsylvania Barn* (1955). From his wide research in both Europe and America, Shoemaker came to the conclusion that the hex signs were "pure and simple decorative motifs." As such they had no underlying program—that is, they were not used for magical purposes.

Like all other ethnic groups in America, the Pennsylvania Germans did believe in the powers of witchcraft. They brought from Europe traditional strategies for dealing with witches and for protecting their property against evil forces. In his reasoning against the theory that hex signs were actually put on barns to ward off witches, Professor Shoemaker pointed out that the hex-sign belt is really a limited area, with Lehigh, Berks, Bucks, and Montgomery counties at its heart.

> If there were any basis to the witch angle, wouldn't it be awfully peculiar that half of the Pennsylvania Dutch Country only believes in warding off hexes and the other half doesn't? Moreover, isn't it plain, common sense that magic, wherever it is practiced (and no one would deny its existence in the Pennsylvania Dutch Country)—isn't it plain common sense, I say, that a farmer would NOT parade his mysterious doings before all the gawking world to see. No, witchcraft and all that hangs together with it, is a very, very *secret* matter, all of it surviving underground, well hidden from view to all but the initiated. Anyone with the slightest insight into human nature must sense how utterly preposterous is the whole hex sign story.

John Joseph Stoudt (1911–1981), the pioneer folk-art scholar of the Pennsylvania Dutch country, defended the theory that the hex signs had meaning. His highly symbolist interpretations of Pennsylvania Dutch folk art appeared in a long series of books from *Consider the Lilies, How They Grow* (1937) to *Sunbonnets and Shoofly Pie* (1973). To Stoudt the inner meaning of the signs had nothing to do with witchcraft. They issued instead from the mystical theology of Europe. Like many Dutchmen, Stoudt took offense at the alleged connection with witchcraft.

> On all sides one hears the sordid story that the markings on Pennsylvania Dutch barns are the signs put there to keep the witches away. Without mincing words, this is slander on the Pennsylvania Dutch perpetrated by outsiders who, riding through the lovely countryside of Eastern Pennsylvania, are hard put to explain why such lovely farms, such well kept fields, should be marked by what they consider to be talismanic signs.

Of course, for Stoudt, it was a New England Yankee who was to blame!

> Wallace Nutting in his dilettante's book *Pennsylvania Beautiful*, was the first one to say that these designs were placed on the barns to scare witches away. The present writer has interviewed 165 people over 70 years of age living on farms where barns are decorated, and not one was willing to admit that these barn-designs were placed there to scare witches away. One old Lehigh County potato grower said that the nonsense about witches originated with city newspaper writers who were careless with the truth. Another old lady was waiting for the woman writer from Philadelphia to give her a piece of her mind! One man said that he had heard his father call them *Dullebawne*—tulips! An old lady said they were *Blummensterne*—flower-stars!

Dr. Stoudt felt that if the designs were really "hex" marks, then why should they appear on Bible covers, tombstones, and other "potent" religious artifacts that certainly needed no protection against witches?

Stoudt found in the signs not a pagan meaning but rather a Christian one. While his symbolist theory has been attacked lately as forced—certainly not every hex sign can possibly represent his "divine lily" of the "Age of the Holy Spirit"—Stoudt was not entirely alone in his thinking.

Dr. Preston A. Barba (1883–1971) of Muhlenberg

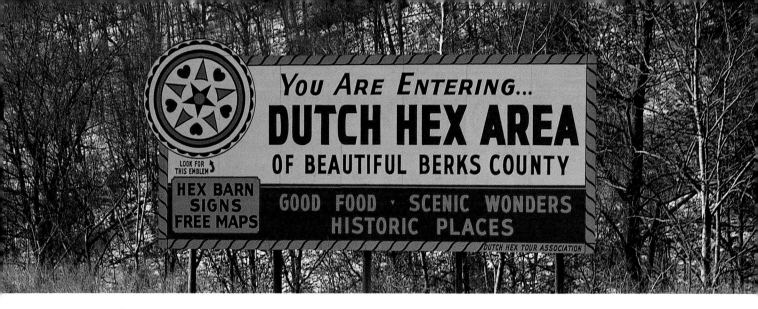

11. Hello, Tourists! The "Hex Highway" parallels Interstate 78 for most of the length of Berks County. Billboards like this are mostly found around Hamburg, the major town along this route and the home of the Dutch Hex Tour Association.

12. Hex-sign kit. One of several designs offered to the home arts-and-crafts hobbyist. (Roughwood Collection)

College, who was well aware of the European scholarly controversy, traced hex signs to paganism but not to witchcraft. In an address in Pennsylvania Dutch, titled "Unser Scheiere" (Our Barns), given before the 1948 Berks County "Versammling" (an annual meeting held completely in Pennsylvania German dialect), he separated himself from the *Hexafoos* crowd. However, he appeared to have joined the German proponents of the sun-wheel theory:

> Today people have little understanding of such things and yet we should hold the ancient signs in esteem because our forefathers honored them and looked on them with respect as holy symbols. No, they were not "just for nice." These signs grew naturally out of our forefathers' own hearts. So it would not do us any harm if we were to see these ancient signs even today for what they were in earlier times: Signs of the mighty power which slumbers in winter, awakens again in the spring and brings new life to nature. In summer, it lets the grain and fruit ripen, and then goes to sleep again in the winter, in an eternal circle or ring, which itself is the most beautiful proof in nature of our God. Whoever is of this opinion, must agree that the stars painted on our barns are nothing but prayers. But *Hexafiess* [witch's feet]? No, no, a thousand times no! Let other and more ignorant people believe in that!

All these hex-based and symbolist theories do not take into account that one cannot attribute to the Pennsylvania Dutchman of the present day exactly the same attitudes toward symbols that his fur-clad forefathers took in Europe, either during the Middle Ages or in pre-Christian times. Symbols may continue in use in a culture for aesthetic reasons, even after their

original spiritual meanings have been lost, and yet retain aesthetic content.

By the 1940s, the scholars' war over the hex signs had reached a draw. Regardless of meaning, the signs themselves were accepted by the Pennsylvania Dutch themselves as symbolic of "Dutchness," a potential not overlooked by Pennsylvania's tourist industry. Dr. Arthur D. Graeff (1911–1981), a Pennsylvania German scholar and by birth a Berks County Dutchman, wrote in his column for the Reading (Pennsylvania) *Times* of May 13, 1946:

> The barnscapes are part of the peculiar heritage of the people of Southeastern Pennsylvania. You will not find their equal or their likeness in any other part of the world, not even in Europe. Nowhere will one find the geometric figures, the stars, teardrops and sunwheels which our forbears used so artistically to break the monotony of color which would otherwise appear on an 80-foot expanse of painted boards. They are as much our own as windmills belong to Holland, castles to Spain and thatched roofing to Ireland. Let's keep them for sentiment's sake.
>
> Second, let's keep them for their practical value too. Our painted barns become a financial asset to our entire community. How? As an inducement to the tourist trade. People travel thousands of miles to see the survivals of French peasantry in the Gaspé Peninsula to the north of us; they dream about visiting the missions in California and write epics on the grandeur of the plantation manors of our colonial Southland. Let our local Chambers of Commerce have something unique to tell the world about when inviting visitors to Berks and Lehigh! It will mean cash in the pockets of all of us, cash from distant places, not merely cash resulting from trading dollars with each other.

Graeff's encouragement was echoed by many others worried about the presentation of Pennsylvania German culture, but little did he realize that the radical mushrooming of the hex myth would result from tourism after World War II. One thing is certain: The new mythology was evidently here to stay.

Today, in Pennsylvania, the tourist can take "hex-sign tours," marked out with route numbers in printed guides along the "Hex Highway" (old U.S. route 22) in northern Berks County. This scenic route through the hex heartland was developed by the Dutch Hex Tour Association of Hamburg, Pennsylvania, which hoped to build tourism in the area.

Not only was the tourist invited to see the hex signs, he was encouraged to buy replicas of them for his own use. At gift shops across the state, hex signs with individualized meanings are offered for sale by the tens of thousands—now printed on disks for easy transport to New Jersey, or New England, Ohio, or Oregon, where they appear on everything from suburban split levels to garages. If the tourist prefers, he or she can buy a Hex Sign Kit and paint one's very own. And of course, there are now endless racks of hex-sign jewelry available for purchase, along with multitudes of trivets, paper napkins, place mats, and other souvenirs, all sporting the hex-sign motifs.

13. From the Berks County "Fersammling" program (1983). The "Fersammling" is an annual all-dialect gathering, the purpose of which is the enjoyment and preservation of the dialect. The placement here of the dialect translation of "America" in a frame of hex signs illustrates the union of national loyalty and ethnic identity. (Roughwood Collection)

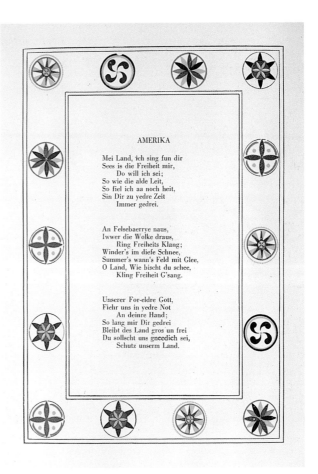

AMERIKA

Mei Land, ich sing fun dir
Sees is die Freiheit mir,
 Do will ich sei;
So wie die alde Leit,
So fiel ich aa noch heit,
Sin Dir zu yedre Zeit
 Immer gedrei.

An Felsebaerrye naus,
Iwwer die Wolke draus,
 Ring Freiheits Klang;
Winder's im diefe Schnee,
Summer's wann's Feld mit Glee,
O Land, Wie bischt du schee,
 Kling Freiheit G'sang.

Unserer For-eldre Gott,
Fiehr uns in yedre Not
 An deinre Hand;
So lang mir Dir gedrei
Bleibt des Land gros un frei
Du sollscht uns gncedich sei,
 Schutz unserm Land.

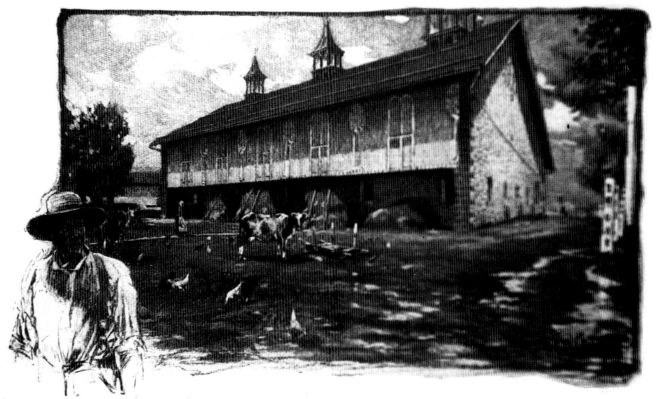

14. Dunkard barn. This fairly accurate portrayal of a hex-sign barn illustrating Nelson Lloyd's "Among the Dunkards" in the November 1901 issue of *Scribner's Magazine* is the earliest known view of hex signs to appear in a national magazine. (Roughwood Collection)

All of this represents the second level of the hex-sign phenomenon: the tourist dimensions. Judging from the souvenir pamphlets, the range of designs still includes the classic or traditional stars, but numerous new patterns have also evolved. Among these are the Oak Leaf Sign, with eight oak leaves and four acorns; the Distelfink (a development from the traditional bird in other genres of folk art); and even the Irish Shamrock Hex Sign. As described in a pamphlet by "Hexologist" J.E. Herrera, *Hexology: The Art and Meaning of the Pennsylvania Dutch Hex Symbols*, the latter conveys the following powers:

> The shamrock is naturally a sign for good luck surrounded by smooth round lines for an easy life. The two distelfinks make for a double portion of good fortune, while the [3] tulips mean faith, hope and charity or a number of ideas expressing fidelity to one's fellow men or his family. The small heart suggests love for one's brother in mankind.

Other hex signs illustrated by Herrera are the Fertility Hex; the Sun, Star and Rain Hex; the Rosette or Love Hex; the Double Rain Hex and Luck Symbol; the Friendship Hex; the Hex Sign for Rain; and others promising Life and Love, Love and Marriage, Power, Plentiful Harvest, Lucky Stars, and Peace and Contentment.

The Hex Sign as Ethnic Symbolism

A third theory proposed by scholars to explain the meaning of Pennsylvania German hex signs treats the subject from the development of ethnic identity. This is the most recent of all the theories about the hex sign, yet as more and more scholars sift through historical evidence, it seems increasingly plausible. The Pennsylvania Germans, like all ethnic groups positioning themselves in relation to their American neighbors, developed symbols to denote their ethnic identity. Badges of ethnic identity are useful to outsiders because they enable quick recognition of what is or is not Pennsylvania Dutch. Equally, these same symbols minister to the Dutch themselves, giving them recognizable projections of their own inner spirit, that is, a key to who they are as a people.

Like every other aspect of ethnicity, such ethnic symbols are often complex in meaning. Ethnic identity involves both *personal* identity—one's sense of kinship to one's group—and *group* identity. On the side of personal identity, the farmer who handsomely decorates his barn with hex signs does so because he is proud of his farm and its well-kept buildings. Secondly, the farmer's individual pride and sense of worth shades over into his sense of group belonging. For him, the hex signs become the symbols of his Pennsylvania Dutchness, of his ethnic group, and of his sense of belonging to it.

Viewed historically, the hex-sign phenomenon may indeed have been connected with the sharpening of Pennsylvania German ethnic consciousness in reaction to nineteenth-century cultural tensions. The Civil War, for example, was especially difficult for the Pennsylvania Germans. The plain sects were confronted with the dilemma of pacifism while nonpacifist Pennsylvania Germans often found themselves fighting against people of German ancestry, especially in the Valley of Virginia. The mid-century also witnessed attempts by the Commonwealth of Pennsylvania to rid the Pennsylvania Germans of their distinctive culture, using the state school system to mount a systematic stamping out of the German language.

The diverse groups making up the Pennsylvania German community reacted to these stresses in their own ways. The plain sects initiated the process of codifying plainer forms of contemporary fashion into a "sect" uniform. This plain code is still with us today. About the same time, the church groups began painting hex signs on their barns and incorporated Pennsylvania German motifs in the Victorian architectural "gingerbread' on their houses. Both Pennsylvania German groups thus made public statements about their cultural affiliations. As attention has changed in this century from national groups to ethnic groups, the Pennsylvania German decorative motifs have, in the fullest sense, become "ethnicity markers."

The symbols of the Pennsylvania Dutchman's sense of belonging, as with other ethnic groups, include a range of artifacts, customs, and expressions. In the early twentieth century, in addition to the farmer with his painted barns, a school of literary spokesmen arose for the culture in the form of the Pennsylvania novelists. Foremost among these were Helen Reimensnyder Martin, Elsie Singmaster, Georg Schoch, and Nelson Lloyd—all Pennsylvanians of dyed-in-the-wool Pennsylvania German stock. In wrestling with the question of how to portray Pennsylvania "Dutchness" in fictional form, these local writers, whose efforts coincided with the general flowering of regional fiction, put together a kit of ready-made ethnic symbols that included the hex sign.

In their attempt to give local color to their settings, novelists of the Pennsylvania Dutch country sprinkled their stories with props from the culture: witches and powwowers, stern fathers, austere plain sectarians, a whole gallery of shrewd Dutch farmers, and their evenshrewder wives. In expressing their "Dutchness," characters often used Dutch-English dialect. Their creators even put together what has since become the culinary canon of accepted Pennsylvania Dutch folk foods, and—what concerns us most directly—they described the decorations on the Dutchman's barn for readers across the nation.

One of the earliest examples of this trend toward ethnic identification with barn decorations appeared in "Among the Dunkers" by Nelson Lloyd, published in

15. Turn-of-the-century hex-sign illustration. This was one of the illustrations for Elsie Singmaster's story "Big Thursday," which appeared in the January 1906 issue of *The Century.* Such local-color stories brought hex signs to the attention of a national audience. (Roughwood Collection)

Scribner's Magazine for November 1901. After describing the differences between the various plain sects, he concentrates on describing a Dunker love feast that he claimed to have attended in a barn in the Lebanon Valley. The barn was "one of those great white structures with green shutters, that so distinctly mark our Pennsylvania landscape." Hex signs are not mentioned specifically, but the article illustration showing the barn where the meetings are held, sports a high supported forebay with a row of six beautifully drawn hex signs.

Like much of the later tourist literature about the Dutch, Nelson Lloyd's article contained some indisputable historical facts, along with a great many misconceptions. The Dunkers, like the Mennonites and Amish, do not today normally allow hex signs on their barns. Did any of them slip past the strictures of their bishops in 1900? We cannot answer that now. But we note Lloyd's fictional account of the Amish "blue gate"—the earliest known reference to it in literature. He related that "not all in the valley are going to Dunker preaching." Some are going to the "Mennonite bush-meeting," or to the River Brethren services,

> or to the white farm-house with the gates of blue. Within those blue gates the Amish are to worship, and, if their ancient custom had its inception in truth, one could not choose a better place, for it has been hallowed by the visit of many a passing angel, who, marking the heavenly hue of the entrance, has stepped aside to bless the home there.

According to current tourist literature, the Amish paint their gates blue when a daughter comes of marriageable age.

Georg Schoch's "The Christmas Child," in *Harper's Monthly Magazine* for April 1906, also brings in barn decorations. In it, a farmer's wife ventures into the barn at midnight on Christmas Eve to hear the animals talk, with unexpected results. The novelist describes a great "Swiss Barn" (as the Pennsylvania German barn was called into the 1950s) with "its red front, painted with moons and stars." It "looked patriarchal; it had its own pastoral and dignified associations."

Elsie Singmaster's classic short story, "Big Thursday," perhaps one of her best, deals with the Great Allentown Fair and its place in the hearts of the Pennsylvania Dutch. It appeared in the January 1906 issue of *Century Magazine*. The illustration by Leon Guipon, showing a Pennsylvania landscape, features a barn decorated with three huge hex signs—a barn typical, in fact, of those found near Allentown.

What these literary offerings accomplish with their illustrations is a mood of "Dutchness." By its very presence, subtle or express, the hex sign is meant to convey a certain psychological impact.

Subtle, but ever present, this theme of ethnicity and symbolism was carried forward in the 1920s by one of Pennsylvania's most influential regional authors. Indeed, the tourist mecca that southeastern Pennsylvania has become today is due in part to the nostalgic and pleasant discovery of "things Pennsylvania Dutch" by Cornelius Weygandt (1871–1957). His books, *The Red Hills* (1929), *The Blue Hills* (1936), and *The Dutch Country* (1939), have become minor classics of American regional literature. Weygandt was himself a Pennsylvania Dutchman who spent a long career as professor of English literature at the University of Pennsylvania. An avid collector of country antiques, he roamed the Dutch counties summer and winter absorbing local flavor and writing charming essays about his discoveries.

It was Professor Weygandt and his books, more than any single source, that developed the Wallace Nutting view of hex signs. In one of the essays in *The Red Hills*, Weygandt described his own feelings about being caught in a Pennsylvania barn during a violent thunder storm:

> Were there not symbols on the barn? They would keep the lightning away. The barn had stood there a hundred years on the open hilltop, with no lightning rods and no high trees nearer than the pines before the house a hundred yards away. Six-lobed the symbols were, in weathered lead that was still strikingly white against the ironstone red of the wooden front. Six-lobed they were, within their circle of four-foot diameter, the six petals of the conventionalized tulip that is the sign manual of all good things in our folk culture. They were on the south side of the barn, and only four of them, not the miraculous seven that keep away all harm. Yet they had kept away the lightning for a hundred years, and they were, no doubt, still potent, as sure in their efficacy as anything in life may be.

Expert that he was in Pennsylvania Dutch folk art, Weygandt even discovered the connection between the tulips on fraktur and the six-lobed design in use as a barn symbol long before John Joseph Stoudt.

Barn symbols are prevalent in many parts of "Dutch" Pennsylvania. They come down close to Philadelphia, but they grow less plentiful as you cross the Susquehanna, until in Franklin County, where there are so many "Dutch" things of fine quality, they are far to seek. The symbols are supposed to keep lightning from striking the barn that has them painted on its wooden sides, and to prevent the animals housed in the barn from being bewitched, or *"ferhexed"* as we say in the vernacular.

He was of the opinion (again before Stoudt) that some of the barn designs had their origin in Rosicrucian symbolism, while others were related to the "wheel of fortune," the four-leaf clover, and the pomegranate.

The final word in the scholars' war over the meaning of hex signs has obviously not been uttered. Because the theories are continuing to develop, to push out in new directions, attracting new meanings in the process, hex signs are worthy of further study. We turn now to the questions of the historical origins of the hex sign in Pennsylvania and its geographical spread in and beyond Pennsylvania's borders.

The Hex Sign in Pennsylvania

The eventual appearance of the hex sign on the Pennsylvania barn depended on several external historical factors. These included the development of a specific type of barn with large wooden surfaces to decorate with painted designs and the availability of inexpensive commercial paint.

Like the hex sign itself, the Pennsylvania barn has gone through several stages of development. As late as 1798, the majority of barns on Pennsylvania farms were built of logs. As farmers of the young nation became more affluent, they replaced these unpainted log structures with larger stone or brick barns with frame forebays. As paint became available in the 1830s, the Pennsylvania Germans, like other American farmers, began to paint their barns. The earliest reference to a painted barn in Pennsylvania is the comment of Prince Maximilian of Wied, speaking of the Allentown area in 1832–1834, that the frame portions of stone barns in the area were "frequently painted of a reddish brown color." So far, painted barns, but no reference to decorated (i.e. hex-sign) barns.

Circumstantial evidence exists that barns must have been decorated as early as the 1830s, but dated evidence for actual hex signs does not appear until after the Civil War. Perry Ludwig, a Berks County barn painter interviewed around 1910, recalled decorating a barn in 1867. The earliest dated illustrations of hex-sign barns come from the county atlases published in the Centennial era of the 1870s.

Dates as early as 1850 are painted on several decorated Pennsylvania barns. Yet there is uncertainty because these dates may be the dates of construction; the decorations and dates could have been applied later. One Berks County barn, for example, bears a worn star over which the date "1873" has been painted. The star, the date, and the farm's name, which have also

16. Fegley farm. This earliest known print of a hex-sign barn is taken from the 1875 Schuyl-kill County Centennial atlas. (Roughwood Collection)

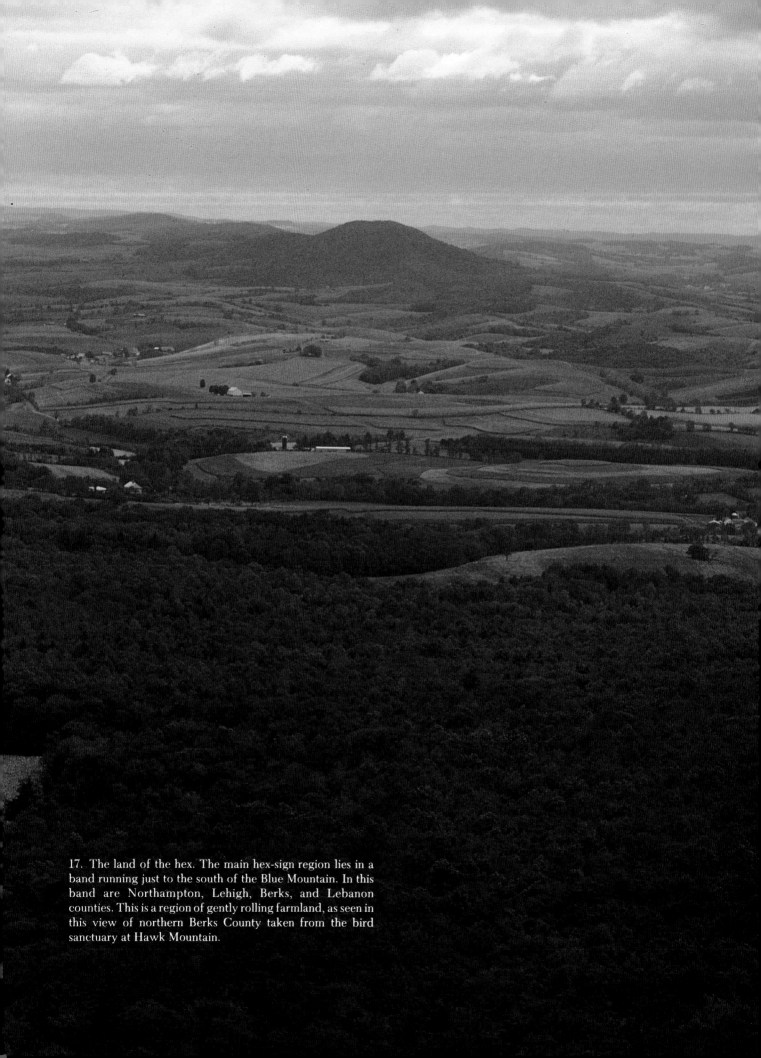

17. The land of the hex. The main hex-sign region lies in a band running just to the south of the Blue Mountain. In this band are Northampton, Lehigh, Berks, and Lebanon counties. This is a region of gently rolling farmland, as seen in this view of northern Berks County taken from the bird sanctuary at Hawk Mountain.

18. A study in technique (near Hamburg, Berks County). This receding star is typical of the designs painted by Milton Hill, who first painted this design around 1910 and who died in 1969. Clearly shown in this illustration are the scribe marks made in the wood when the sign was first laid out. These marks make it easier for people to repaint the signs at a later date. Someone had painted the date 1873 on this barn over the hex sign. While that date may very well be the date the barn was built, it does not mean that the hex sign was originally painted before 1873. The date could have been added during some later repainting, several of which are in evidence here. The barn was originally red, and whoever painted it white must have been planning to repaint the star, for that has been carefully painted around.

been painted over this same star at various times, have all weathered so that three layers of decoration and lettering are visible at the same time. At first glance, it would appear that the sign was painted before 1873. Unlike carved datestones built into a structure when it was erected, a painted date is unreliable as evidence.

The practice of decorating barns among the Pennsylvania Germans seems to have been most prevalent from 1900 to around 1960. Not enough evidence exists at present to gauge the popularity of the tradition before 1900. Since 1960, there have been fewer and fewer painters applying decorations directly to the barn itself. However, with the mechanization of

agriculture and the obsolescence of traditional barns, hex-sign painting entered a radically different phase.

By 1940, several painters began making hex signs on portable, easy to mount discs of wood, masonite, or metal. While many Pennsylvania Germans view disc signs as purely "tourist art," this new and less expensive

19. Summer boarders from Philadelphia at Treichler's (Hereford, Berks County). Notice the man with hunting rifle and dogs, another with his fishing line, and the people all ready for a nice country horseback ride. This barn is now in the middle of a modern mobile-home park. (Collection of Schwenkfelder Library)

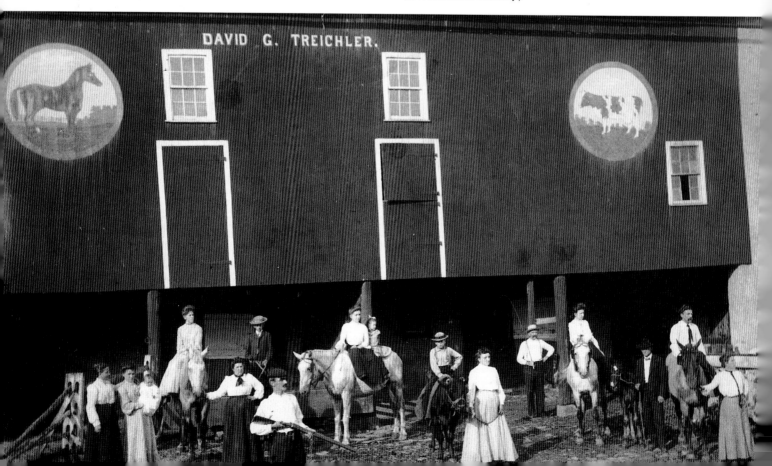

form of sign has been adopted by many farmers in lieu of expensive painting or repainting signs directly on the barns. Although disc signs expand the repertoire of design motifs to include such images as the Tree-of-life, the Distelfink, and Hearts and Flowers, the designs most often chosen by farmers are traditional geometrical patterns.

The Geographic Spread of the Hex Sign

Our fieldwork investigations show that barn decorating was most common among the Lutheran and Reformed groups of Berks, Lehigh, Schuylkill, Carbon, Lebanon, Bucks, Northampton, and Montgomery counties. The plain sects, the Amish and Mennonites of Lancaster County, for example, did not decorate their barns, although hex signs do appear in the northeastern corner of Lancaster County, a section of the county with more church people than plain sects. A few signs also appear in the northern part of Chester County.

This ten-county region of southeastern Pennsylvania is the largest and best-known area of hex signs, but hex signs appear in other parts of the United States as well. Not surprisingly, these localities were mostly settled by people of Pennsylvania German descent, the two largest being central Ohio and the Valley of Virginia, the latter centering on the lower Shenandoah Valley and adjoining areas in West Virginia. Both Ohio and Virginia lie in the path of two different waves of migration from Pennsylvania. The earlier one turned south along the Appalachian Mountains and penetrated as far as the Carolinas and even Georgia, while the other wave went due west through Ohio into the Midwest. The barn decorations found in Ohio are most like those found in Pennsylvania. The Virginia decorations and those found in West Virginia form their own set of common motifs, of which only the Five-point Star is shared with Pennsylvania.

Painted hex signs are also scattered along the path of Pennsylvania German migration within Pennsylvania, from Dauphin County (which has Harrisburg for its county seat) to as far west as Bedford, Somerset, and Washington counties.

20. A map of Pennsylvania showing the hex-sign region in the southeastern part of the state.

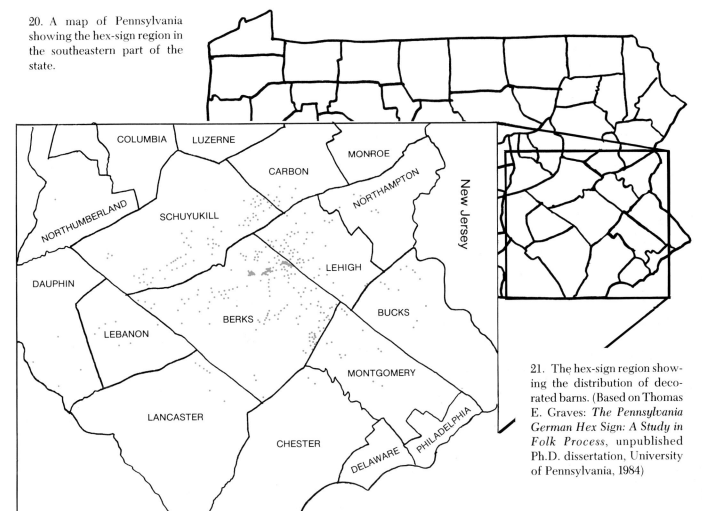

21. The hex-sign region showing the distribution of decorated barns. (Based on Thomas E. Graves: *The Pennsylvania German Hex Sign: A Study in Folk Process*, unpublished Ph.D. dissertation, University of Pennsylvania, 1984)

19

The Forms of the Hex Sign

Hex signs are normally placed on the so-called "forebay" of the Pennsylvania German barn. The forebay is the upper level of the barn that projects out over the stable area. This side of the barn is often considered the "front" of the building. Three, or even as many as five, hex signs are evenly placed across the upper half of the forebay, although many other elaborate combinations exist. For example, hex signs are sometimes found on the gable ends or on the "back," or bank side, of the barns, their placement and number dictated by the style of the barn and by local and personal taste. The decorations themselves average four feet in diameter, ranging from three feet to as large as eight feet.

22. Appliquéd star (Somerset County). In Pennsylvania's southwestern counties, especially Somerset, Bedford, and Washington, stars are cut out on a jigsaw and then attached to the barns. In Somerset County these stars also often serve as "date stones." (Roughwood Collection)

23. Types of hex signs. These designs represent the most common motifs found on traditionally painted barns.

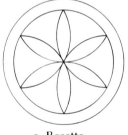

a. Rosette

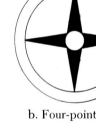

b. Four-point Star

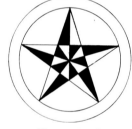

c. Five-point Star

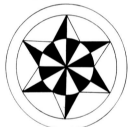

d. Six-point Star

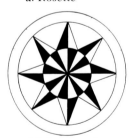

e. Eight-point Star

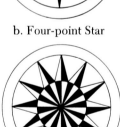

f. Twelve-point Star or "The Twelve Months"

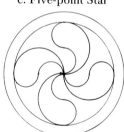

g. Swirling Swastika

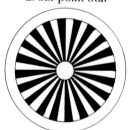

h. Wheel-of-Fortune or Barn Wheel

24. Forms of hex-sign embellishment.

a. Internal Scalloping

b. Multiring Border

c. Dots between the Spokes and External Scalloping

d. Star within a Star

Most hex signs fall into one of eight design categories. Some designs are simply rendered, others are highly embellished. Embellishments form a subset of design elements that can be used with any of the basic design categories. One of the most common embellishments is the addition of crosses, dots, or smaller stars between the "rays" of the primary star patterns. Others include such features as scalloping or triangles on the circular borders. Some embellishments are found only on certain designs, such as the "teardrops" found on Four- and Eight-point Stars. Still other embellishments act as a painter's "signature," as in the case of the squiggly lines in the border of Milton Hill's earlier work or the overlapped scalloping used by Harry Adam and later by Milton Hill.

With hex signs spread over such a large region, it is possible to discern distinctly localized patterns that may range from one township to adjoining sections of several counties. For example, the Five-point Star is most common in eastern Schuylkill County, the Six-point in western Lehigh, and the Eight-point in eastern Berks. When first cataloguing the distribution of the Rosette, it appeared randomly, like buckshot, on the map. However, it soon became evident that while this design is common throughout the hex-sign region, it is most popular in western Schuylkill County. Conversely, the Five-, Six-, and Eight-point Stars have areas of localized concentration, but are also found randomly in many counties.

Some designs show a limited geographic range. The Twelve-point Star, called locally the Twelve Months, is found almost exclusively in central Berks County. The Wheel-of-Fortune, also called the Barn Wheel, is mostly found around Boyertown in Berks County. Other localized designs often straddle or cross county lines. The Four-point Star and the Swirling Swastika, for example, extend in an arc starting around Boyertown and sweep through Berks, Lehigh, and Bucks counties.

In other places, designs overlap. The Rosette, Swirling Swastika, and Wheel-of-Fortune coexist in the area surrounding Boyertown. Other designs avoid regions dominated by others. For example, there are few Rosettes or Five-point Stars in areas with Six- and Eight-point Stars.

It is unclear exactly how many or even which designs first appeared before 1900. The only designs known to have been used before 1900 are the Eight-point Star mentioned by barn painter Perry Ludwig and the Rosette illustrated in the Schuylkill County Centennial atlas. Photographic evidence, common after 1900, records a particular set of designs from the early part of this century that has continued in use to the present. Another set has developed since 1940 that includes hearts (either between the rays or in the center of a

star), "tilted" Five-point Stars (where the top ray points to one o'clock instead of midnight), the curvilinear Rosette combined with the Straight-sided Star, and the nongeometrical forms.

It is possible that further research may push the origins of this new group of motifs back even earlier. For example, a couple of designs originally thought to have been created after 1940 are now known to date from an earlier period. One example is the full side view of a horse appliquéd to the barn, as evidenced in period photographic postcards. This design, rare today, was apparently more popular around 1900–1910. Another example is the Oak Leaf. First popularized by Johnny Ott after 1947, the Oak Leaf was documented as early as 1938 by Ann Hark in *Hex Marks the Spot*.

The Disappearing and Reappearing Hex Sign

Naturally, the aesthetics and values of both the Pennsylvania Germans and rural Americans in general have changed over the last 200 years. The Pennsylvania Germans are now famous for their decorated furniture and fraktur, most of which was created in their classic folk-art period, that is, before 1850. As they adopted different forms of expression, such as "English" ideas about furniture finishes, printed birth certificates, and Victorian popular designs, Pennsylvania Germans lost

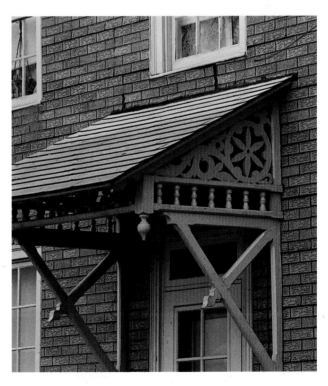

25. Stick-style hex sign (Schuylkill County). A Rosette, complete with scallops, adorns this Deer Lake residential stoop.

26. Suburban hex sign (Schuylkill County). Where the new disk signs have come into use, an unspoken aesthetic has arisen that places them near the back door, on small storage sheds, or, as here, on garages.

interest in the artifacts of earlier generations. In time, the chests, pottery, and pie safes were relegated to the attic or barn. With the fall from grace of these examples of classic Pennsylvania German art, other artifacts assumed the common motifs. The best known of these latter forms are the quilt and the decorated barn.

While barn decorating has declined in the last twenty years, the last forty years have seen a steady revival in some traditional folk-art genres, such as painted furniture, fraktur, and pottery. These revival crafts appear to be an essential part of the current ethnic self-expression of the Pennsylvania Germans.

Since World War II, family farming in Pennsylvania and the rest of the country has lost ground continually to agribusiness. Under this economic pressure less attention is paid to the aesthetics of the farm. While some farms are still kept in good condition, many farmers now wait longer to repaint their barns, if they repaint them at all. For the hex sign, this has meant that many are now literally fading from sight, lost when a

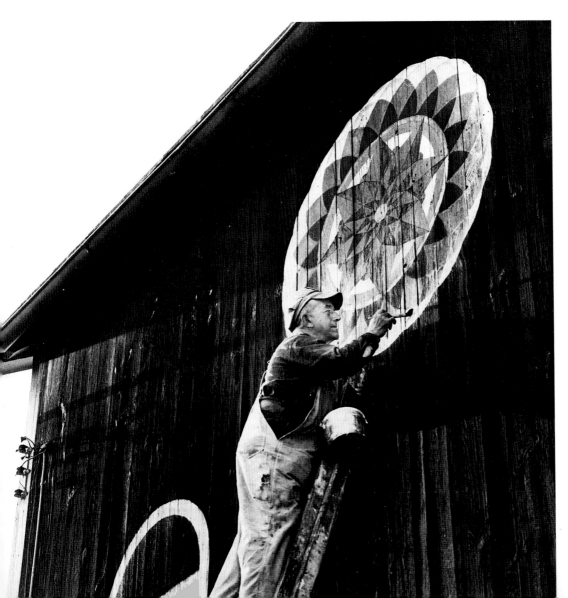

27. Milton Hill of Virginville, Pennsylvania, painting a barn. (Courtesy Pennsylvania Folklife Society)

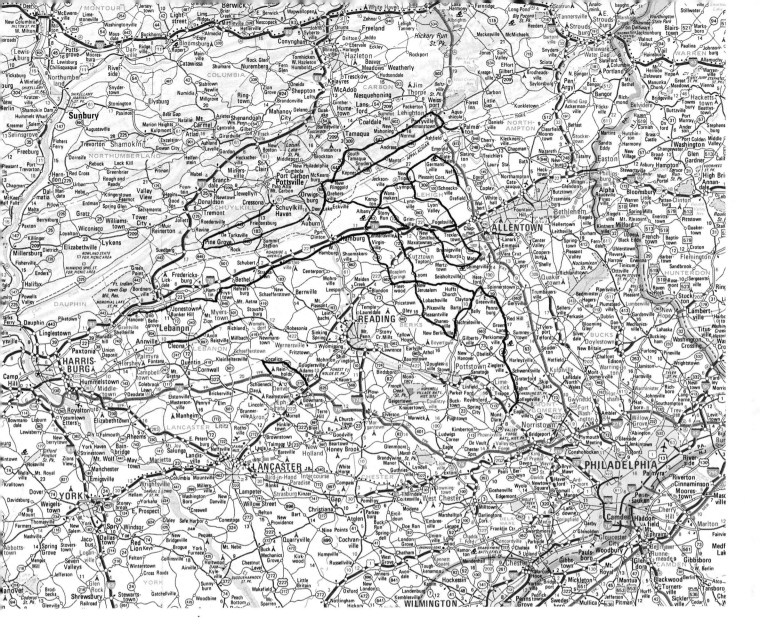

28. Where to go to see hex signs. This map indicates some of the major routes through the hex-sign country that will give you a tour of the major designs. Decorated barns tend to occur in clusters, so it sometimes happens that you drive awhile between hex signs. This is even true on Hex Highway (old Route 22). Also, it would be rewarding to deviate from the marked routes in northern or eastern Berks County and in western Lehigh County.

29. The Amish hex machine by Robert J. Byrd. A cartoonist's view of the selling of Pennsylvania Dutch culture taken from *The Sunday Bulletin Magazine*, July 30, 1967. (Roughwood Collection)

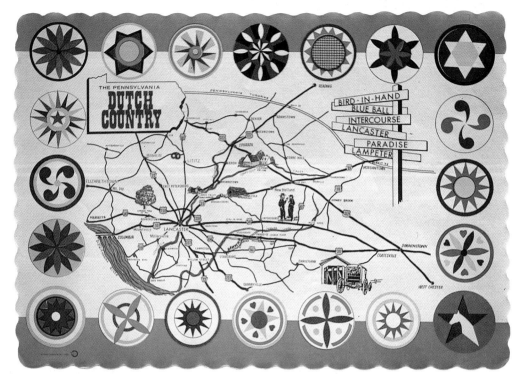

30. The Pennsylvania Dutch country. The map on this 1962 placemat shows central Lancaster County, an area farmed by Amish and Mennonites. It mixes plain sects with hex signs, even though the plain groups do not paint them on their barns. (Collection of Thomas E. Graves)

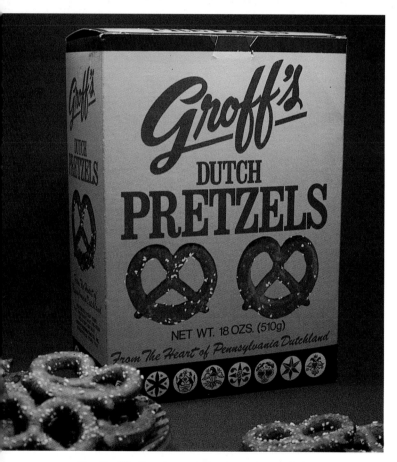

31. Groff's Dutch pretzels. Hex signs sell food as well as souvenirs. A whole range of local products now marketed nationally uses hex signs as symbols of "Dutchness." (Photograph by Don Yoder)

barn is quickly spray painted one solid color, when it collapses, or when it is dismantled.

Another modern development that has disfigured many decorated barns is asphalt shingling. According to barn painter Milton Hill in a 1950s interview, many barns, both old and new, were covered with these shingles, especially during the 1940s and 1950s. A similar trend continues today in the form of aluminum and vinyl siding. Often, when an old barn receives new siding, its decorations are covered over, although occasionally the farmer covers every side except the decorated one. Only two barns are known where hex signs were painted directly over asphalt shingles. The more usual method of decorating a shingled or resided barn is to nail disc signs to it.

Urban expansion is a related problem. As Philadelphia, Allentown, Reading, Hamburg, and Lebanon grow, and as their surrounding suburbs spread farther into the countryside, farm buildings, decorated and undecorated, are demolished. The toll is heaviest around Allentown, especially toward the south where urbanization is creeping to meet the northward corridor of expansion from Philadelphia.

The Amish and Mennonites also contributed to the demise of the hex sign. These plain groups do not believe in the outward, public display of decoration. When they purchase a farm with hex signs, the signs are one of the first things to disappear. Some Mennonite families will maintain the hex signs if they were there when they bought the farm, but most Mennonites and

32. Johnny Claypoole painting a four-foot barn sign. Claypoole is seen painting one of a set of signs commissioned by a Berks County farmer to replace the worn signs painted directly on the barn. The design and colors were copied from the originals.

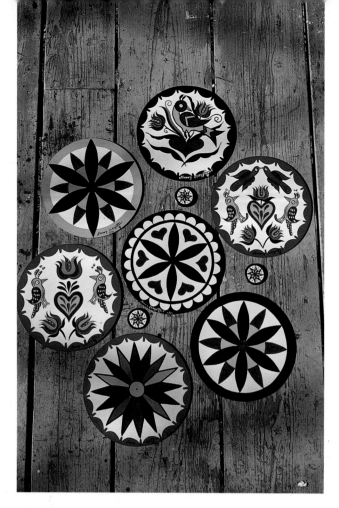

33. A selection of Johnny Claypoole's designs. (Courtesy of the artist)

34. William Schuster at work in his Emmaus, Lehigh County, studio.

Amish simply whitewash the barns, covering over any external decoration. As a further part of their aesthetic of plainness, these sects often remove all interior and exterior "gingerbreading" on their farmhouses, even if it clearly dates from the eighteenth century.

The Tourist Discovers the Hex Sign

With the growing popularity of the automobile, weekend jaunts to the country became fashionable. By the 1930s, feature stories about the Pennsylvania Germans and their hex signs began appearing regularly in Sunday newspaper supplements and in such national magazines as *The Saturday Evening Post* and *National Geographic*. Although illustrations of decorated barns had occurred in popular literature as early as 1900, they appeared before touring had become widespread. Furthermore, while the early illustrations were meant to highlight local-color fiction, those in the 1930s were clearly tourist oriented.

Since 1940, the tourist industry has become a major factor in Pennsylvania's economy. The effects of this industry have been twofold. Most noticeably, the literature produced for sale to tourists or to promote the region has created the following illusions: 1) that all Pennsylvania Germans are Amish; 2) that the Amish use

hex signs; and 3) that hex signs are intended to keep away demons, witches, and evil spirits. However inaccurate these misconceptions about the Pennsylvania Germans may be, they were convenient for the tourist industry because each of these ideas represented a different aspect of the total Pennsylvania German culture, which, condensed together, conveyed an easily recognizable "image."

Hex signs, by being thrown into prominence by the tourist industry, were given new life when grafted onto the Amish image. Mass-produced signs were created by companies that silk-screened the designs onto disks. Still other signs are custom-created by artists who sell them at various craft shows around the state.

Use of these newer motifs blossomed within the Pennsylvania German community to such an extent that hex signs appear on Pennsylvania German commercial foods distributed both locally and nationally, as well as on commercial buildings and outdoor advertisements to mark firms as "Dutch" owned.

The use of hex signs as ethnicity markers and the use of their designs by the tourist trade represent opposite ends of the same cultural phenomenon. Just as the outsider buys objects nominally made for use within the community, the Dutchman has begun to use and display "Dutch" souvenirs. This interplay creates an image of the Pennsylvania Germans which helps, rightly or wrongly, to reinforce the Pennsylvania German self-image.

The Contemporary Hex-Sign Painter

In the 1940s, artists began to paint signs on disks made of masonite, plywood, or metal. One of these early disk painters was Johnny Ott (1891–1964), the owner of the Lenhartsville Hotel in Berks County, who began painting in 1947. Having started by painting designs on

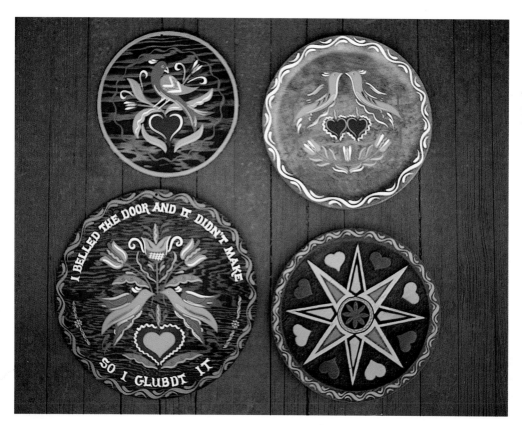

35. Hex signs by William Schuster. (Collection of Thomas E. Graves)

36. Ivan Hoyt at Kutztown. Ivan Hoyt creates hex signs at the Kutztown Folk Festival. A selection of his signs hangs on the walls.

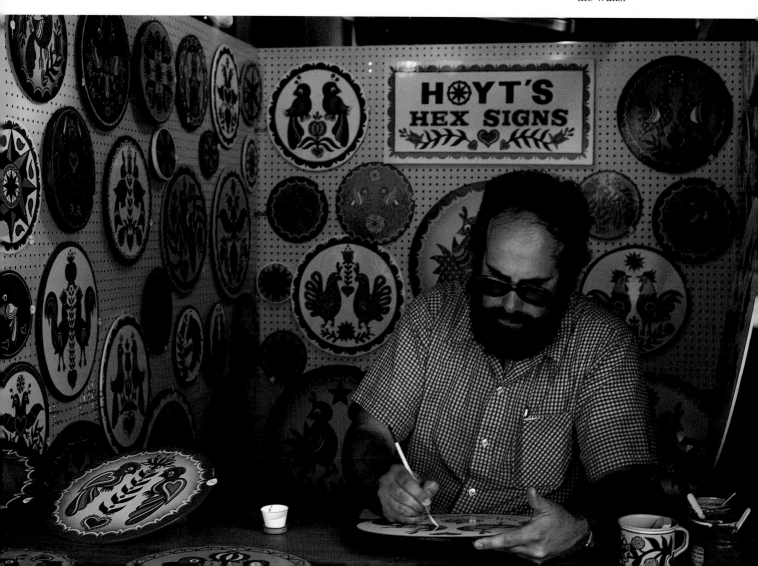

furniture for his family and friends, he soon became more famous as a painter than as an innkeeper. In addition to creating his own designs, Ott created designs for Jacob Zook, of Paradise, Lancaster County, who began silk-screening hex signs in 1952. Zook's early signs bear the signature: "Zook & Ott." Ott was a colorful figure, well remembered by many people in southeastern Pennsylvania who fondly refer to him as "Chonny." Although many barns sport his colorful designs, Ott was only a disk painter; he never painted directly on barns.

A number of painters who had started their careers by working directly on barns began painting on disks as well. Among these were Harry Adam of Hamburg, Milton Hill of Virginville, and James Hitcock of Palm.

Today, at least a dozen painters make disk signs, among them Johnny Claypoole (b. 1921) of Lenhartsville, Berks County; William Schuster (b. 1922) of Emmaus, Lehigh County; and Ivan Hoyt (b. 1950) of Wapwallopen, Luzerne County. All three of these artists appear yearly at the Kutztown Folk Festival, which draws a nationwide crowd. Each of these painters can roll off the names of the states and foreign countries from which their customers hail.

Few living hex-sign painters are now willing to go up on a barn and paint new signs or repaint old ones. Johnny Claypoole is one exception. He has been painting signs since 1962 and had taken lessons from Johnny Ott just prior to Ott's death. He also does toleware, wooden benches, blanket chests, milk cans, and anything else that customers might commission. He has painted a few barns "from scratch" and has also repainted many barns. Some of his most visible work includes hex signs at Hershey Amusement Park and on the Elephant House in the Philadelphia Zoo. Claypoole, who hopes that some of Johnny Ott's character has rubbed off on himself, was once quoted:

I like what I am doing, I love it.
I dream up a lot of my ideas. Once you know
the symbols you can make up your own things.
An artist has a right to put what he wants and
you can do it if you know the symbols.

Claypoole is one of those painters who started painting hex signs simply out of a personal interest and without any previous artistic training. Now, it is his vocation.

William Schuster has been painting signs for over thirty years and has taught most of his family to paint, including a grandson and a future son-in-law. Schuster, like Ott, started by making designs for friends and family. Having originally gone into business as a sign painter and a carpenter, he has only been making hex signs commercially for the last fifteen years. Schuster

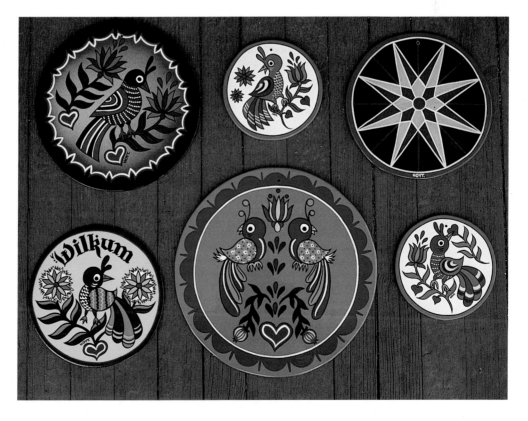

37. A selection of hex signs by Ivan Hoyt. (Collection of Thomas E. Graves)

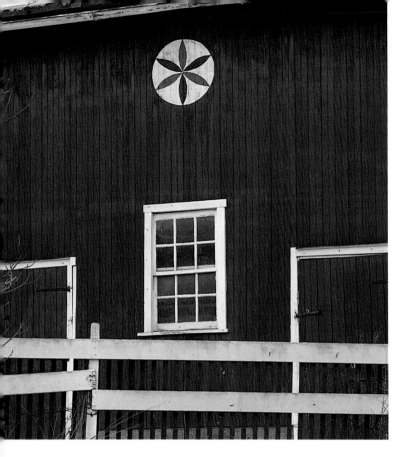

38. Rosette (near Murray, Lebanon County). The Rosette is the most widespread design in Lebanon County and the adjacent western end of Schuylkill County. This Rosette has no circular border, which is unusual.

has painted one barn, but he prefers to paint disks in his studio because of the expense and the need for scaffolding in barn painting—not to mention the backlog of his other work. Schuster also decorates a wide assortment of trays, plaques, garden markers, and other objects. Because of his experience as a sign painter, one of the "signatures" of Schuster's style is his personalization of items for customers. He will add their names, a special date, or anything else they might want.

Ivan Hoyt has been painting signs for about thirteen years. He is an art teacher who, like several other painters, began by painting signs for his family. As more and more people requested his work, he devoted more and more time to hex signs. However, Hoyt has remained only a part-time painter. He grew up and learned to paint hex signs in Luzerne County which is outside the geographical area in which they are normally found. While some of his large disc signs have been hung on barns, he has not yet had the opportunity to paint a barn directly, a task he would willingly tackle.

The Meaning of the Hex Sign: Some Personal Views

Pre-Christian Sun Wheels; symbols of the Holy Virgin or of Christ; protection against fire, illness, witches, evil, and the Devil; markers of personal or ethnic identity; an evolution of a folk art form; "pure decoration"—just what, at this point, can we say that

the hex signs mean? Evidence exists linking hex-sign motifs to all of the above ideas. Conversely, all the theories that have been put forward over the last hundred years have some basis in fact. Perhaps the question should be asked more directly: What do hex signs "mean" to the contemporary painters and to the people whose barns the hex signs grace? And how are they interpreted by prominent Pennsylvania German spokesmen and contemporary scholars?

Johnny Claypoole breaks the question of meaning down into two parts: "Do they have *symbolic* meaning?" and "Are they *magically* effective?" He very much believes that they have symbolic meaning.

Rosettes actually are very powerful according to the old, ancient religion. Rosettes are to ward off evil, disease, pestilence, bring good luck and health. Solid-black border or scalloped border usually mean the same. Solid border is usually the sea of life, smooth sailing through life. Now if this was a solid-black border, black is "Unity in Christ." Most of the signs, the original signs, have religious significance. They were to ward off evil.

Most of them just say good luck.

Purple would represent the Robe that Christ was crucified in. And your green and yellow would be fertility of life, crop abundance, fertility of fields. White is purity. Black circle is your "Unity in Christ." Some put a red circle, it's just a matter of color.

The rose and tulips pertain to the same thing, to faith.

While he believes strongly that the motifs used on hex signs have symbolic meaning, he does not believe that they have any real power in and of themselves.

I've done signs, to help chase ghosts away, oh, for gamblers, to make money. I don't know, I make something up for them, they like it. I won't [mess] with them, give them a lot of noise. I tell them the facts, like it is and a lot of things like that. If they believe in it strong enough it will work. That's all it is. Like the fertility signs, I still say they wouldn't [work]. They just believe in it so strongly they get preg-

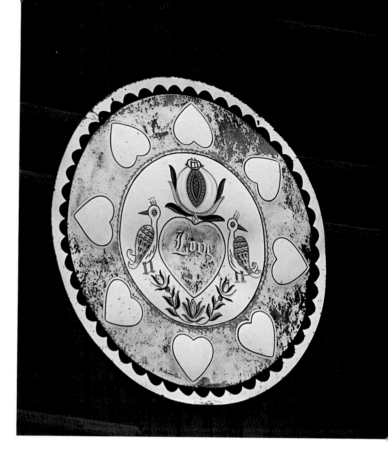

39. "Love and Marriage" by Johnny Ott (near Kutztown, Berks County). This sign is typical of those painted by Johnny Ott (1891–1964). The rule of thumb among farmers is that barns need to be repainted about every ten years. This sign is in decent condition for having been exposed to the weather for at least thirteen years when this picture was taken in 1977. Although farmers have accepted the modern disk signs, it is not common to find them in such untraditional places as seen here blocking the door on the forebay. Of course, these doors are no longer needed to provide a draft for threshing, but many farmers still use the various doors on the forebay to toss out feed and to provide light. Painting the trim on a barn is common. Usually this means outlining the doors, windows, and the outline of the structure in a solid color: white for red barns and green for white barns being the most common. Scalloped borders are rare.

nant. But they claim, "oh, it worked, it worked." Good, I'm glad to hear that. I want some for money, make one work for me.

I have one woman who I sold an Irish hex sign. She bought it for luck. It was pouring rain. She walked out of the shop. Her and her husband were taking me to dinner. We walked past the Post Office and I heard her scream and [she] jumped down on the pavement and here was a wet ten dollar bill laying down on the pavement. That was just luck. She says "It worked, worked, my sign is working, my Irish hex is working." She went ape. She actually believed the sign brought her that ten dollars.

Mainly, people buy them for decoration, fix the home up. Once in awhile some person gets me to make a sign for an old person with a terminal sickness or something. They said: "John, just put something funny on it. It makes them happy." I say "O.K." As long as it will actually help them and they feel better, good, I'll do it for them. Otherwise, I don't promise no cures or nothing like that. I don't buy it. Only one guy who can do that and that's the man above. That's the way I look at it.

William Schuster will also tell you about the symbolic meanings associated with each design and color, but can the signs actually cause or prevent something? No, they will not. But not all his customers agree. He describes one request:

It's amazing, one time I had a woman come in here, you've heard of powwowing already, and the Pennsylvania Dutch being superstitious

years ago. Well, there's a woman, she spoke with an accent, she had a German accent, not Pennsylvania Dutch, German. She wanted two hex signs. Then she asked me if I worked on them. I couldn't figure out what she meant. I asked her a few times. I said: "I don't quite understand." Then it dawned on me, do I powwow? This [hex signs] has nothing to do with powwowing...I said: "No, I'm sorry." And then she bought two signs, though. She walked out the door. She said: "Now I have to go somewhere else and spend some more money." She is taking those signs somewhere and have someone powwow over them.

Ivan Hoyt does not believe that hex signs are anything more than decoration. Not having grown up with them, he bases his opinion on his own research. However, he says that many of the people who buy signs from him tell him that they want signs for a particular purpose. He tells them that they are purely for decoration and, while some writers say they have this or that meaning, he does not think they do. He once explained:

I find constantly if people want to believe these hex signs have meaning, you can't talk them out of it. You would state to people that they are purely decoration. They don't want to hear this. They want to know which one's a rain sign, which one's good luck...

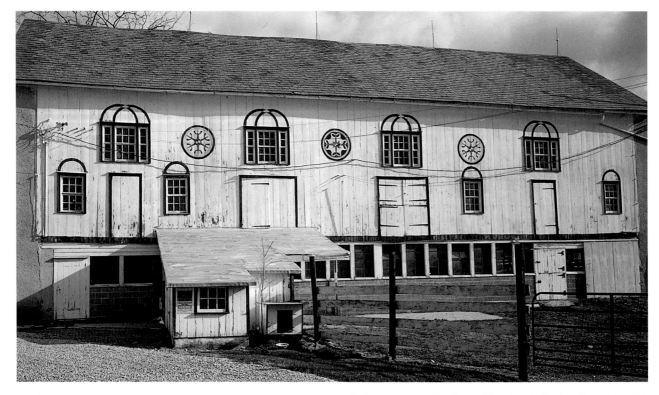

40. Fetterman's Hatchery (Hereford, Berks County). Old pictures of this barn, when it was owned by the Fettermans and had Fetterman's Hatchery painted on it, have appeared in some of the works on hex signs. The designs are typical of the Berks-Lehigh border region. The current owners of this barn plan to keep the barn and the painted designs.

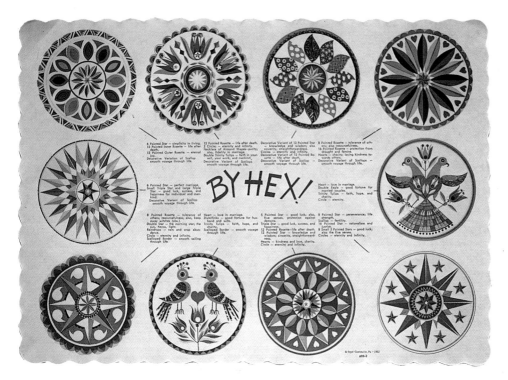

41. *By hex!* A complete description of the design and meaning of each hex sign is given on this 1962 placemat. None of the designs is found on barns in the Pennsylvania Dutch region, but most of them can be found on gift-shop disks. (Collection of Thomas E. Graves)

People are continually requesting signs for particular purposes from these three painters. While not all their customers are looking for a magical talisman, the idea that hex signs are magical has clearly spread into popular culture. Surely, not everyone has read Wallace Nutting's book or the booklets by Jacob Zook or Elmer Smith, all of which discuss the magical meanings of hex signs.

Although we have not interviewed over 170 informants as John Joseph Stoudt once claimed, people living in the hex-sign region have given us differing responses. The most common view is that hex signs have no meaning, that they are just decorations. A few believe that hex signs did have a meaning for those who put them on barns, but that this original meaning is now lost.

At one farm near New Tripoli in Lehigh County, both the housewife and a workhand agreed that the signs were, in the housewife's words, part of "old hexen business, olden-time hexen business." They were convinced that the signs were put there for "hex reasons" by the people who originally decorated the barn. In this case, the farm had come down to the present owner from her great-grandmother. Today, as far as she was concerned, the signs were purely decoration. One of her hired hands pointed out that the stars on the barn, while all the same design and colors, had certain colors reversed, producing mirror images. He said he did not know the significance, but felt that this had been done for a particular magical purpose.

Another housewife stated that her family had bought their Hereford, Berks County, farm with the barn already decorated, some ten years before the interview. She said that for her family the signs were merely decoration, but for the people who painted them they were rich in meaning, and every part of the sign—the design, the placement, and the colors—had special significance. To prove her point, she produced several well-thumbed pamphlets, most notably Elmer Smith's and Mel Horst's popular *Hex Signs and other Barn Decorations.*

A farmer from Alburtis, Lehigh County, thought some hex signs were probably put up to scare away witches, but said that most of them were there for decoration. Of all the people we spoke with, he was the only one to mention that it was only the affluent farmers who had their barns decorated—an interesting point, since it was cost that had kept him from replacing the signs on one of his barns when it was given new wooden siding.

Not all farmers who believe that the signs have some kind of meaning say that their meaning is connected with witchcraft. One farmer, near Churchtown in northeastern Lancaster County, stated that the stars on his barn were part of the trim. He kept them painted because "without the trim, the barn would not be complete." For him, the stars were more than just ornament. They were an integral and necessary part of the barn itself. Without them, his barn would be unfinished, not a whole building. Regardless of what hex signs may or may not have meant at some point in the past, today they speak most directly to the personal, vocational, and ethnic identities of the farmers whose barns they adorn.

Set against this is the popular and tourist literature of the last sixty years that has worked its way into the Pennsylvania German community. This literature has left its mark on what people think concerning hex signs to such an extent that it is now impossible to find individuals whose opinions are not, in some way, influenced by what has been written. We have actually spoken with people raised in central Lancaster County who, ignoring the evidence all around them, have maintained that they always thought the Amish use hex signs!

We thought it would be useful to ask an Amishman whether or not this was so, and if not, then why? Aaron S. Glick, an Amish minister in Lancaster County, provided us with this reply:

Perhaps they're merely nice. But traditionally, we Amish people haven't used hex symbols. For the most part the question hasn't even arisen. It's assumed the nonuse of these symbols is related to the suspicion of past occult significance. It's equally probable their decorative nature makes them seem inappropriate for those of us who prefer unadorned simplicity in clothing, farmsteads, and general life patterns.

This decorative, nonfunctional nature of the symbols is probably the real reason Amish people still don't use the designs on barns or houses because, with the possible exception of tourist gift shops, almost no one seems quite sure if they have any significance at all. Other decorative symbols are used by the Amish people. The bookplates in our old bibles are very decorative. And our ladies' needlework, from samplers to quilts, reflects a wide variety of designs. But generally, these do not include the so-called hex signs.

Clarence G. Reitnauer is a lifelong resident of Hereford Township, Berks County. Widely known as a

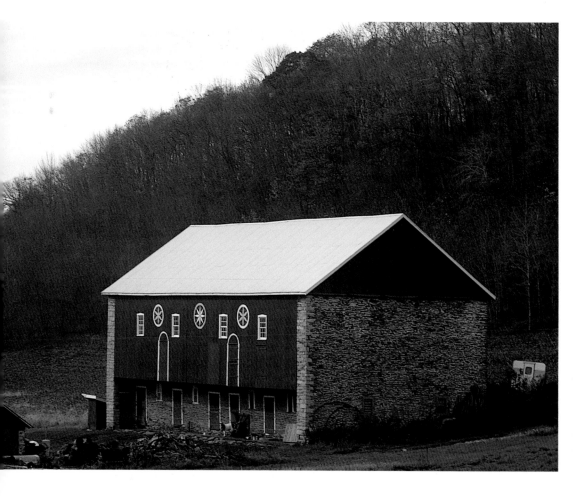

42. Simple symmetry (near Kutztown, Berks County). Barns often have the same design for all their stars. When there is more than one design, it is often the central one that is different.

speaker at dialect gatherings, he has also written a dialect newspaper column for many years using the pen name "Der Shdivvel Knecht" (The Bootjack). He remembers as a boy watching his future father-in-law, John Reitnauer, paint the family's barn with the Four- and Eight-point Stars typical of his neighborhood.

They [the hex signs] are a nice ornament. The first thing I remember was, when I was a small fellow, they painted them on the barn on the farm where I was raised. Then, after the fore-bay was painted bright red, they went right to work and drew big circles on there and they made the ornaments. But I could never under-stand where these "hex signs" would come from because I was always taught and brought up that there is nothing like "hexes" unless you hex yourself. You see, they always said that if you believe hard enough then you could hex yourself.

But this I do know, they sometimes put up peculiar things, even above the cow stables. They used to bore holes into the lintels, pretty big holes, and write things that the witch doctor had told them to, and put this paper in there, and then put in a peg to close it up. And I remember one time at home on the farm this door frame was poor and they tore it down to put a new one in. And here we found something like that and they opened it. But this paper was all crumbled, you couldn't read anything. I've often thought about that.

So, I would say this, a lot of people make a lot of money making them and telling people what the different signs mean. Maybe they're right, I wouldn't condemn them, but as far as I am concerned, I just think that it was for orna-ments. I like to see them. I hope that people will not get me wrong and think that I am just trying to form a new doctrine about it now. Really, I don't know, I don't think they were ever used around here [to ward off witches].

Beatrice B. Garvan, Associate Curator of American Art at the Philadelphia Museum of Art, sees the hex sign in the larger context of European art as well as the

specific rural and ethnic framework of Pennsylvania German culture.

I think that the hex sign on the barn is a very diluted, linear, flat, final expression of the strong Renaissance tradition that came over here with the first settlers. The hex sign just seems to me to be too big now, it misses the richness of their early arts. Their arts are so intimate, so personal, whereas the hex sign is out for everybody to see, it's up there and it's blue and red and white and it's done with a big scribe.

I just feel that the hex sign has to do with our ideas about the "romance" of, I don't really want to say "the good old days" because that isn't quite it. You are still working pretty hard in an agrarian economy, but the hex sign does glorify the focal point of the farm, which is the barn, and decorates for the world to see, not just for the Pennsylvania Germans, but the public world. It celebrates publicly what the Pennsylvania German prayed for privately: luck, love, long life.

They are very beautiful when you drive around the countryside and see them on the barns. But it is important to see the barn without it, to see the whole farm complex. You have that big satisfying circular hex sign there and you can hardly take your eyes off it. There is no question that the Pennsylvania Germans knew that their barns were something special. They spent a great deal of time and money on them. I am sure hex signs had significance. But I do not think that every design that everybody did at every time has significance.

Although of German ancestry, Dr. David Hufford of the Hershey Medical Center of the Pennsylvania State University does not claim to be Pennsylvania German. However, as a medical folklorist, he studies belief systems in depth. His comments on the meaning of hex signs are conjectural, based on his personal knowledge of related areas of belief.

I don't remember the first time I heard the term "hex sign." It was probably about the time I first started graduate school. I very quickly developed the impression that any connection at all with belief was a popular misconception.

Since that time, as I have thought about it, it seems to me very likely that at least a major part of the original intent included supernatural purposes. The potential embedded in the name for them guarantees that supernatural uses for them or meanings applied to them will be re-created over and over again wherever they are found. Certainly there are plenty of people in south-central Pennsylvania, just as there are anywhere else, who have beliefs which have a strong valence for talismanic items. If they bought a farm where there were some, they would possibly attach such significance to them. Being a purist as all graduate students are, I thought, "Boy, if there is some old guy that puts on a thick Pennsylvania Dutch accent and sells these things to tourists then they must be all phoney-baloney."

I reconsider those opinions now. I would say that since hex signs are available, there must be people who purchase them to add them to their property for a combination of aesthetic and blessing and apotropaic kinds of purposes. I certainly know that the use of protective amulets, talismans, and so forth continues to be a vigorous tradition with support from many, many different ethnic groups and from people who are not ethnically identifiable at all. With that as background, then these big, beautiful things distributed for public view all over the area with a name like "hex signs" attached to them must be used fairly often for those purposes.

Whatever the real meaning of the hex sign is, we are left, in the end, with the great Pennsylvania German barns standing, awesome and decorated, in a landscape set against lush cornfields, rolling hills, and blue mountain ridges. From the walls of these huge structures, the hex sign speaks to us and beckons us, as if by magic, into the spirit of the place and into the heart of the people who painted them.

So blue my hills, so misty blue,
So tender sweet the skies above,
So old my hills, so ever new,
So rich with life this land I love.

Here on its warm breast let me lie,
By hex-starred barns and ancient mills,
Where distant heaven bends close by—
Here in my everlasting hills!
 Ann Hark (*Blue Hills and Shoofly Pie*, 1952)

43. Detail of a house in Fischbach (Krpniki), Lower Silesia, Poland, showing six- and eight-petaled Rosettes on the exposed timbers and kneewall. (From Ludwig Loewe: *Schlesische Holzbauten*, Düsseldorf: Werner-Verlag, 1969.)

44. Detail of the decoration on the 1601 Silesian miner's inn. (From Ludwig Loewe: *Schlesische Holzbauten*, Düsseldorf: Werner-Verlag, 1969.)

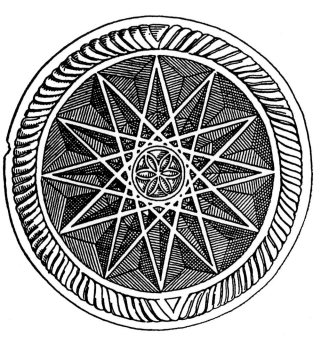

45. Twelve-point Star with a central Rosette carved on a ceiling beam of an Upper Austrian parlor (1793). (From Reinhard Peesch: *Ornament der Volkskunst in Europa*, Leipzig: Edition Leipzig, 1981)

46. Decorated washboard from Upper Austria, carved for presentation as a friendship gift. Note the central overlapping Rosette design, bordered by plain Rosettes. Between Whirling Wheels-of-Fortune stands a Cross, surmounted by a Swirling Swastika. (From Reinhard Peesch: *Ornament der Volkskunst in Europa*, Leipzig: Edition Leipzig, 1981)

47. A decorated German bridal chair (1831) given as a wedding gift to a Hessian bride. (Courtesy Germanisches Museum, Nürnberg, West Germany)

48. Pennsylvania German box (1780–1800). Rosettes were punched into the lid. (Courtesy Philadelphia Museum of Art)

49. Sgraffito plate (1823) attributed to Henry Troxel of Montgomery County, Pennsylvania. The Rosette is bordered by overlapped scalloping, a design element that later appeared on the barns. The inscription reads: "In this dish there stands a star, and the girls are boy-crazy!" (Philadelphia Museum of Art)

50 (opposite). Schwenkfelder fraktur (1818). The prominent swirling Twelve-point Stars are here juxtaposed with the motifs of house and garden. (Collection of Schwenkfelder Library)

51, 52. Hex-sign motifs on Pennsylvania German tombstones (1802–1947). The tombstone in figure 51 was photographed by Don Yoder.

1818

53. Centre County *Taufschein*. This birth-and-baptismal certificate, dated 1800, provides early evidence of multicolored Rosettes combining red, green, and gold, a combination later continued by barn painters. (Collection of Schwenkfelder Library)

54. An early example of a decorated, but forebayless, barn. (Collection of Schwenkfelder Library)

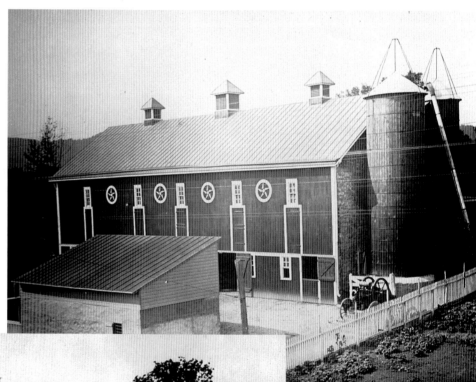

55. The Howard Moser farm, Niantic, Pennsylvania. A fine early farm photograph with a highly decorated barn. (Collection of Schwenkfelder Library)

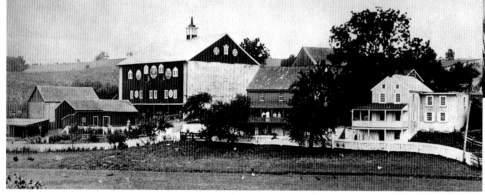

56. The Pennypacker barn. Photographer William Fegley wrote about this barn: "The barn of a century ago. Swiss in style, erected 1787. Situated on the farm of ex-governor Pennypacker, at Schwenksville, Montgomery County, Pa." Regardless of the barn's age, this photograph of around 1910 illustrates the use of multicolored Rosettes. (Collection of Schwenkfelder Library)

57. The Dutch country winery (near Lenhartsville, Berks County). This barn has four examples of "The Twelve Months" spread across its forebay. Unusual are the hearts in the arches. The decorations on this barn were recently repainted by Johnny Claypoole.

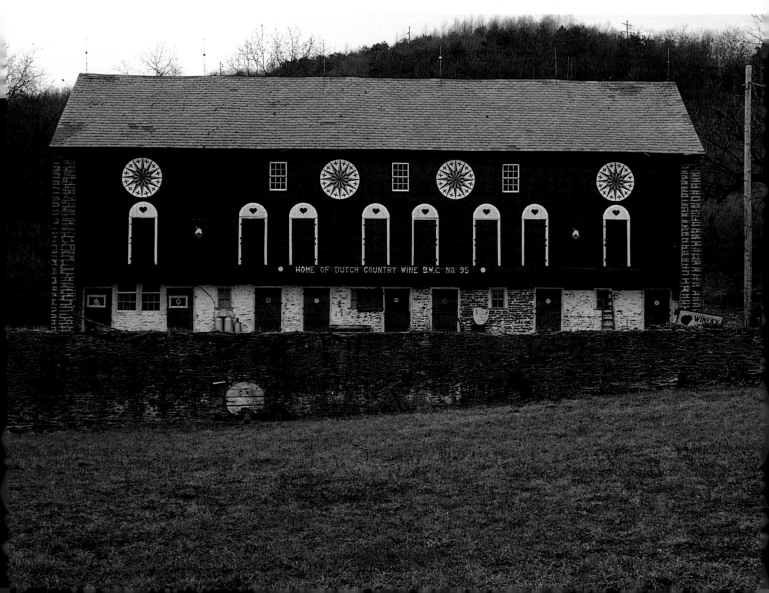

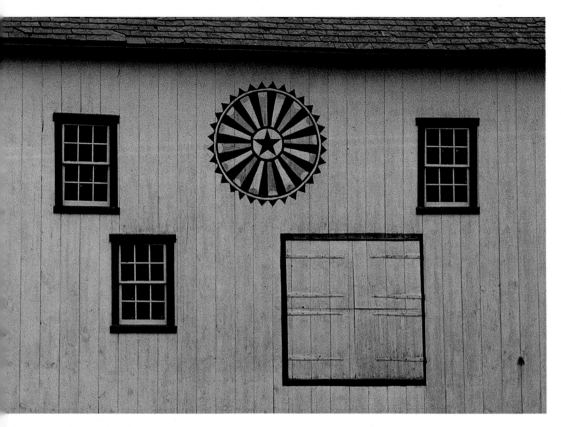

58. Wheel-of-fortune (near Boyertown, Berks County). This wheel has 32 spokes, the commonmost number. Most of the wheels have a central circle which, if filled, generally contains a Five-point Star, as on this barn. This wheel has scalloping on the inside of the border and triangles on the outside.

59. The barn at the Lobachsville Mill, Berks County, which was decorated for Richard H. Shaner, its former owner. (Photograph by Don Yoder)

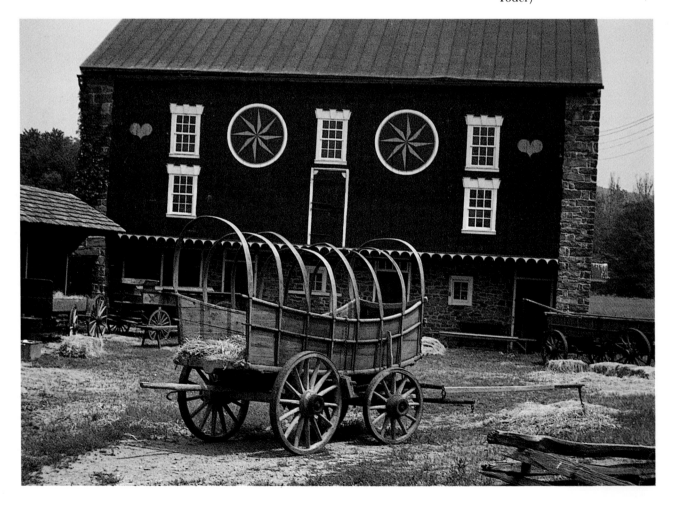

60. A study in red and white (near Shanesville, Berks County). This barn has several different designs on it. On the forebay are two Swirling Swastikas. Between these designs is an Eagle. Painted over the two windows are Rising Suns made from two-thirds of an Eight-point Star. Along the bottom of the forebay are Quarter Suns made from Wheels of Fortune. On the gable end are two Rosettes. Not many barns display such a variety of decoration.

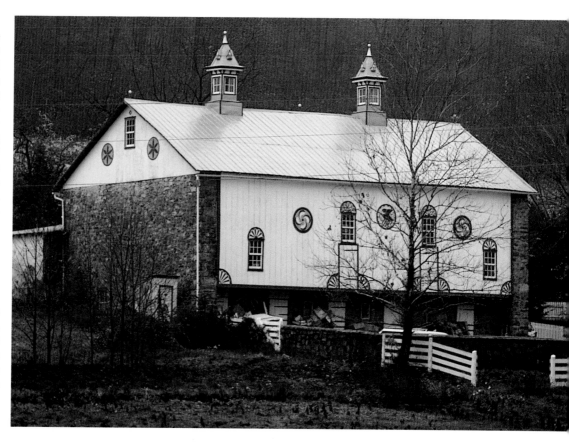

61. Five- and Six-point Stars (Minersville, Schuylkill County). This barn is on the extreme northern edge of the hex-sign region. The Five-point Stars are typical for this county. The central Six-point Star suggests that the barn was decorated after the addition had been built.

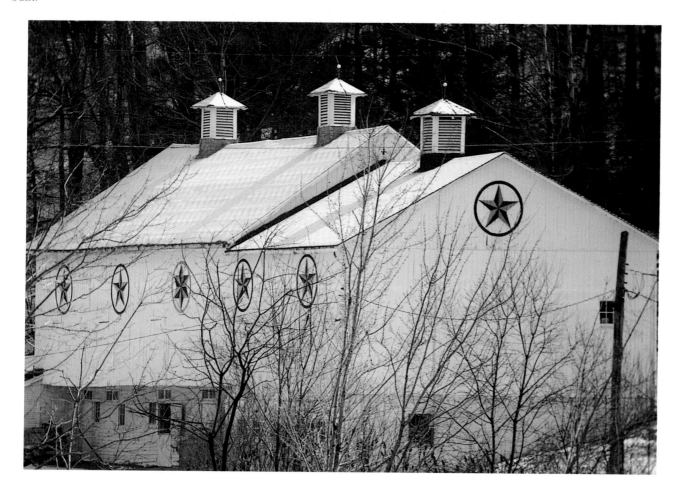

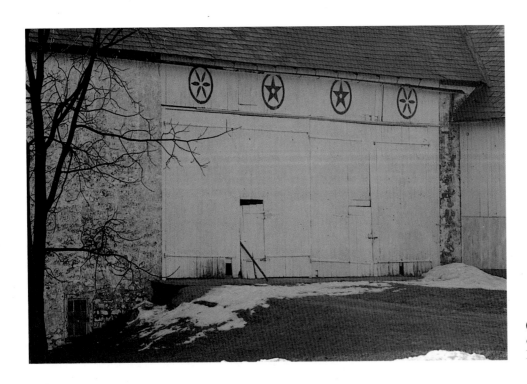

62. Hex signs on the "back," or bank-side, of an Alburtis, Lehigh County, barn.

63. Rosettes and Triangles (near Boyertown, Berks County). Solid-color Rosettes are more common than multicolored ones. The scallops that reach from one petal to the next are also common. Different-size signs on a barn are found most often around the Berks-Lehigh-Montgomery region.

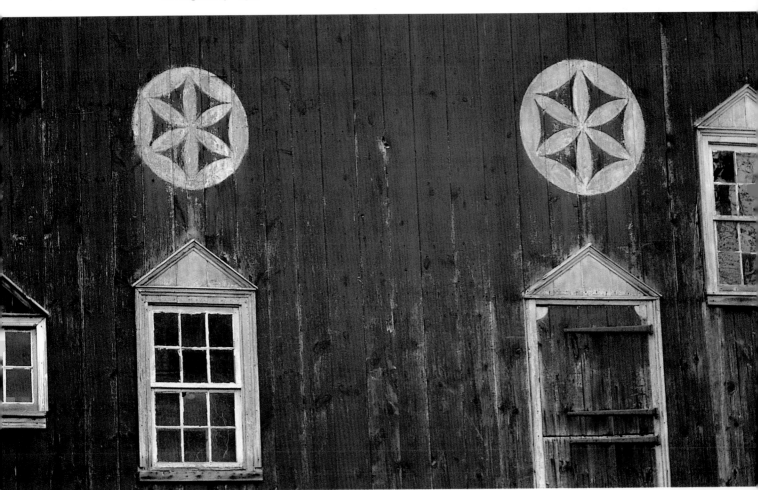

64. A classic Bucks County hood.

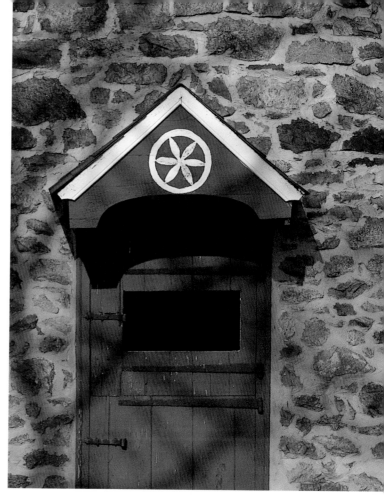

65. Eight-point Star with Rosettes and a multiringed border (near Moselem Springs, Berks County). The narrow rays of this star, which do not touch each other at their widest section, are unusual. The multiringed border, like scalloping, is a common form of embellishment. Hard to make out is the date "1843," which has been painted over in the white triangular arch over the door.

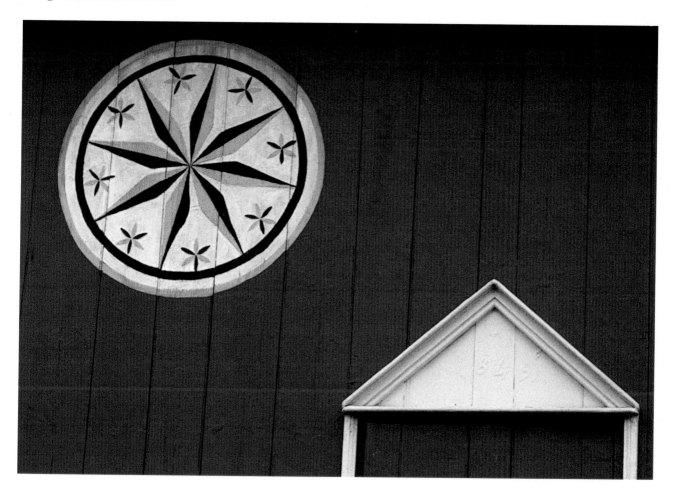

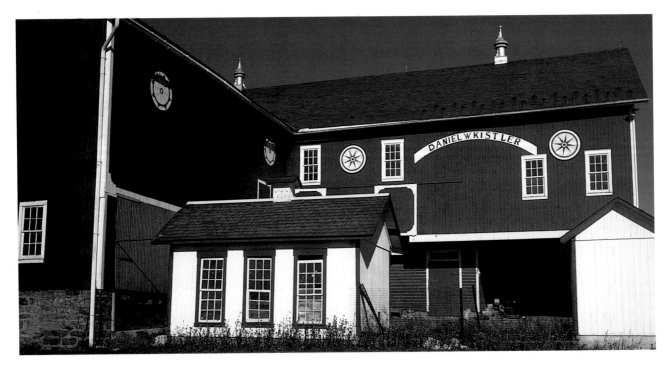

66. The Kistler barn (near Wanamakers, Lehigh County). Here the farmer's name is painted directly on the barn, but the hex signs were painted on disks. It is possible that under these disks are traces of older signs. Replacing hex signs with disks is less expensive than repainting the original signs.

67. Klinesville barn (Berks County). This forebay sports a most unusual execution of the Receding Star motif. More typical is the Eight-point Star on the gable end.

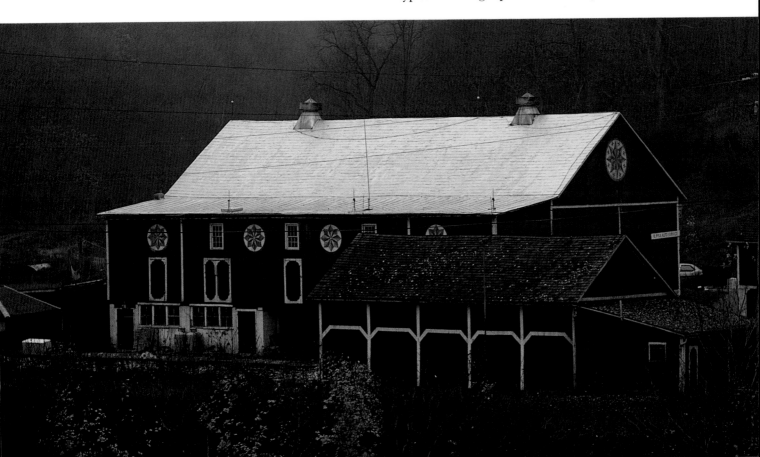

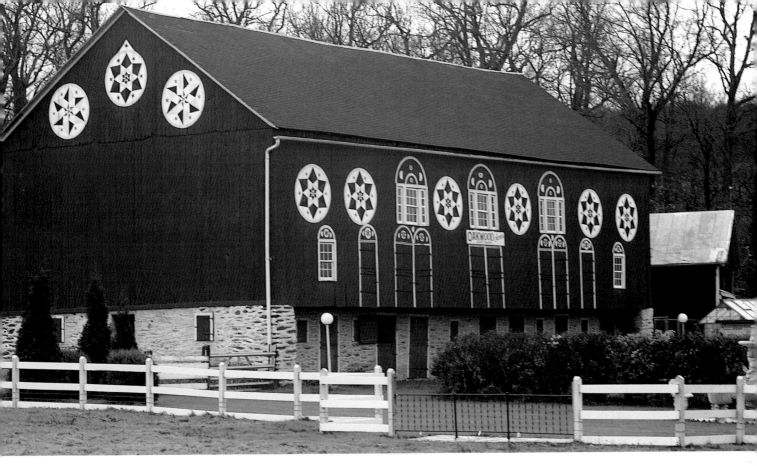

68. "The Most-Decorated Barn" (New Smithville, Lehigh County). This barn has become known as "the most-decorated barn" and has been illustrated in most of the works on hex signs. Unique to this barn are the moons and small designs inside the arches and the triangle above the top star on the gable end. The owner has placed the sign with the farm name Oakwood Acres over two of the arches, hiding some of the original decorations.

69. The Elmer A. Werlee barn (near Germansville, Lehigh County). These Six-point Stars are typical of western Lehigh County.

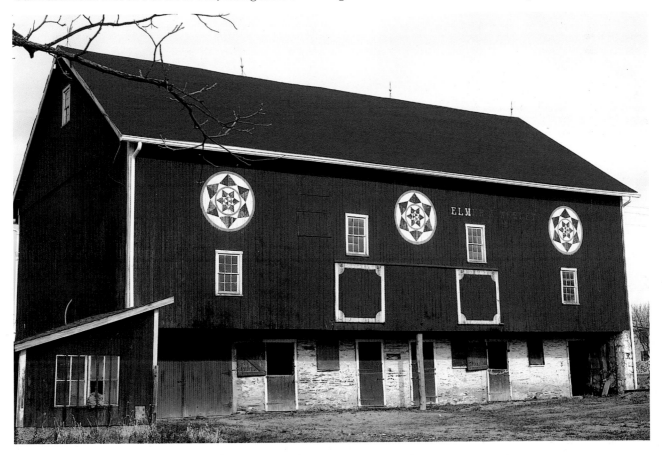

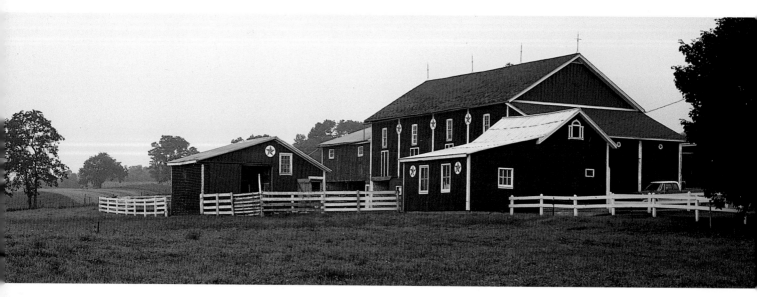

70. Bernville barn (Berks County). Smallish stars placed on painted pillars are found in west-central Berks County. While some of these barns have stars painted right on them, this barn has stars that were painted on disks and then applied to the barn in the places where they would have been painted. The design and placement have remained unchanged while the form of application, the least important aspect of the tradition, has changed.

71. Green on white (near Eckville, Berks County). This barn illustrates the symmetry usually achieved in the placement of windows, doors, and hex signs.

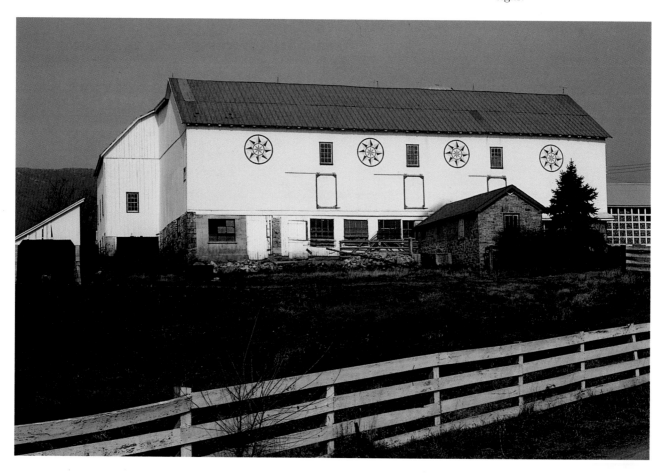

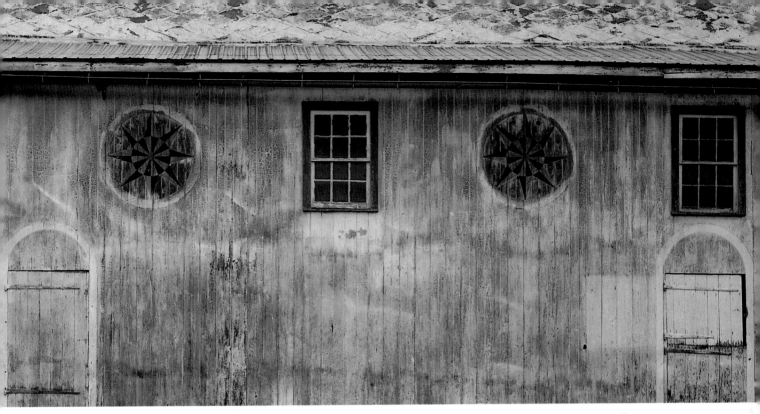

72. When red barns turn white (near Stony Run, Berks County). This photograph shows what happens when red barns are painted white, a color change that is happening more and more in Pennsylvania. The original white lines around the doors stand out. If the trim were to be repainted, these lines would most likely receive a coat of green paint. The farmer has left the original hex signs uncovered and may eventually have them repainted.

73. A star by the "Squiggly-line Artist" (near Krumsville, Berks County). Except for the border, this design is typical of many stars with six, eight, ten, or twelve rays found in central and northern Berks County. There is a central wheel with Rosettes between the rays. Sometimes the Rosettes are replaced with crosses or dots. The border is the "signature" used by Milton Hill on his early hex signs, before he started using overlapping blue scallops. Note the vent in the form of a Maltese Cross above the sign. Vents are common, even on undecorated barns.

74. "The Twelve Months" with yin-yang symbols (near Albany, Berks County). The Twelve-point Star is known in central Berks as "The Twelve Months." While dots, Rosettes, and crosses are common embellishments between the rays of a star, this northern Berks County barn is the only one on which we have seen Oriental yin-yang symbols.

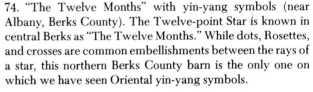

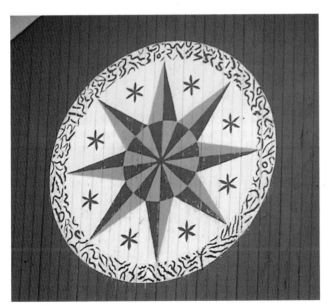

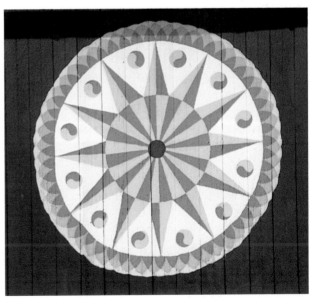

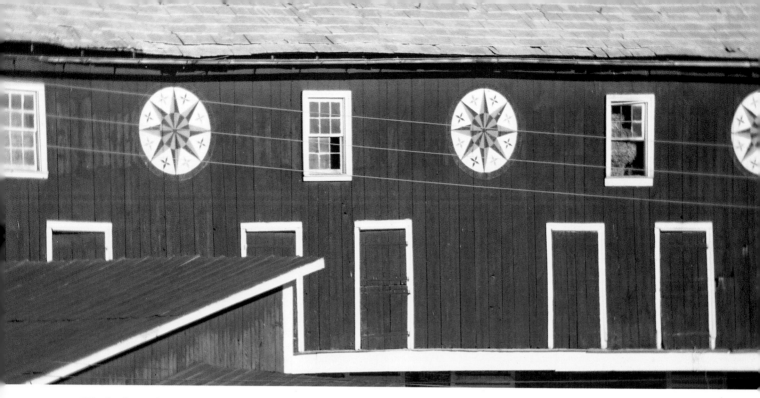

75. Circles and rectangles (near Steinsville, Lehigh County). Just across the county line in Lehigh, these are typical Eight-point Stars as found in central and northern Berks County.

76. Cross with raindrops (Lehigh County). This barn is near Alburtis, not far from the Berks County border. These are typical designs for the region. A plaque in the lower left is dated 1793.

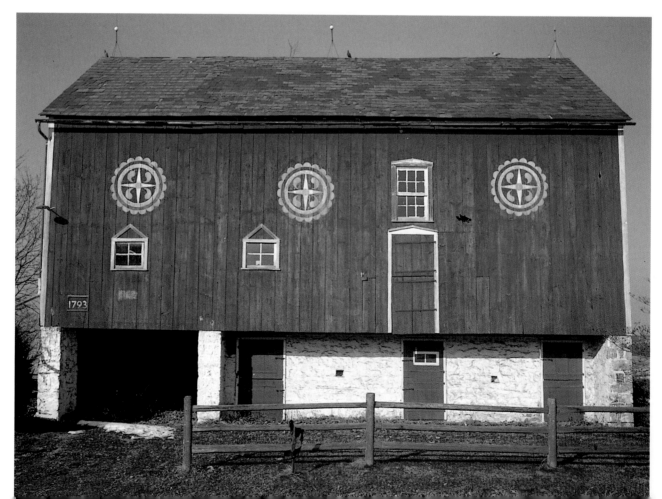

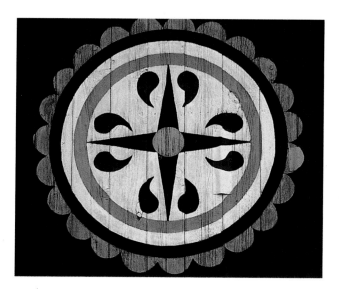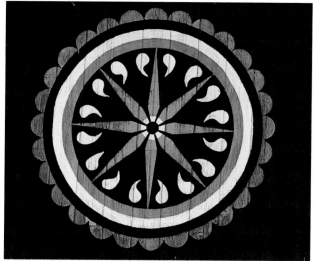

77 and 78. Four-point Star with raindrops and Eight-point Star with raindrops (near Fredericksville, Berks County). These designs, found here on the same barn, are common in the Berks-Lehigh border region. Typical of these designs are the narrow rays, the raindrops (also called teardrops), the multiringed border, and the scalloping.

79. An upper Bucks County barn. The third-story window here aesthetically replaces a central hex sign.

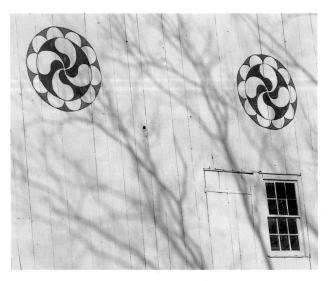

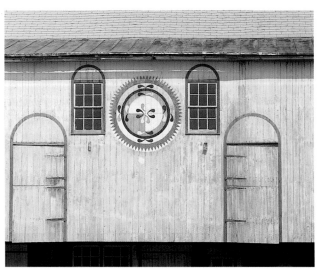

80. A play of color and shadow (Bucks County).

81. Raindrops and more raindrops (near Gilbertsville, Montgomery County). This study in raindrops has a subtle color scheme. The central design, formed with eight drops, can be viewed as four horseshoes or two Swirling Swastikas going in opposite directions. A few signs with this general pattern are found in Montgomery County.

82. Sixteen-point Stars (near Lobachsville, Berks County). This is one of two barns we have seen with Sixteen-point Stars done in the past. The other example, in southern Schuylkill County, is laid out and colored like many of the Eight-point Stars in Berks County, but this barn displays a unique execution and coloring. However, this design is now becoming more common because of its use by Johnny Claypoole.

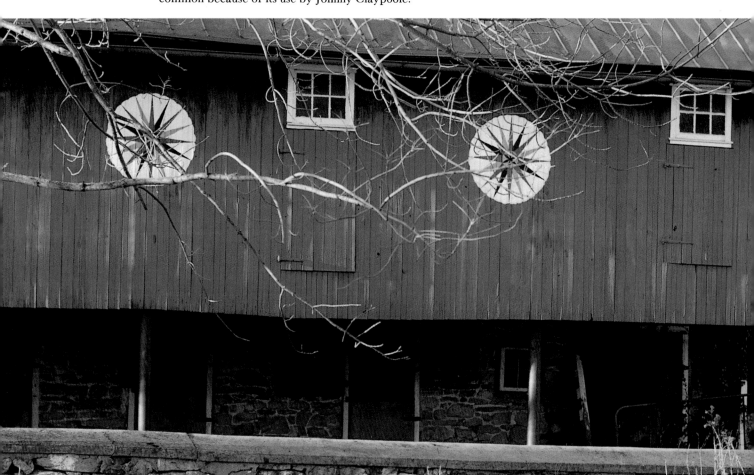

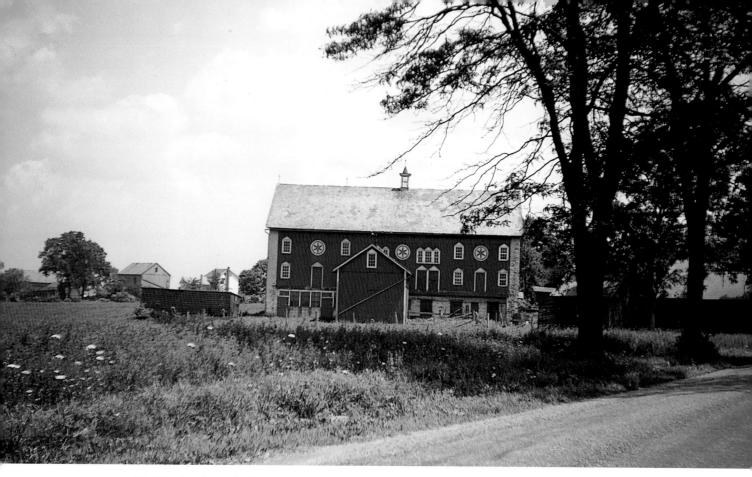

83. This handsomely decorated triple-decker on the Berks-Lehigh border near Alburtis unites Rosettes with triangular pediments, a combination common in the area. (Photographed in 1961 by Don Yoder)

84. "Cocalico Star" (near Swartzville, Lancaster County). In Lancaster County, hex signs are found only in the northeastern corner. The most common design is the Eight-point Star with small secondary points between the main ones. This motif is locally called the "Cocalico Star" after Cocalico Creek. The two signs on this barn are the Cocalico Star with its traditional colors, but they are modern disk signs.

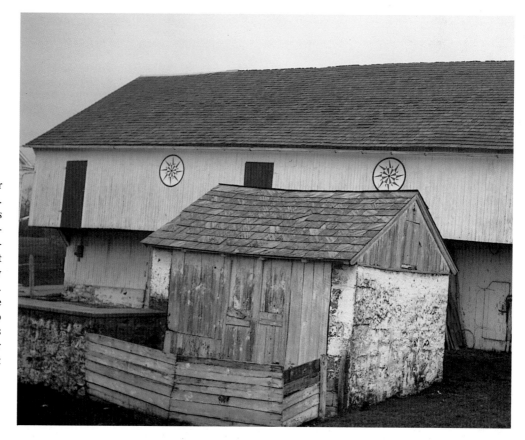

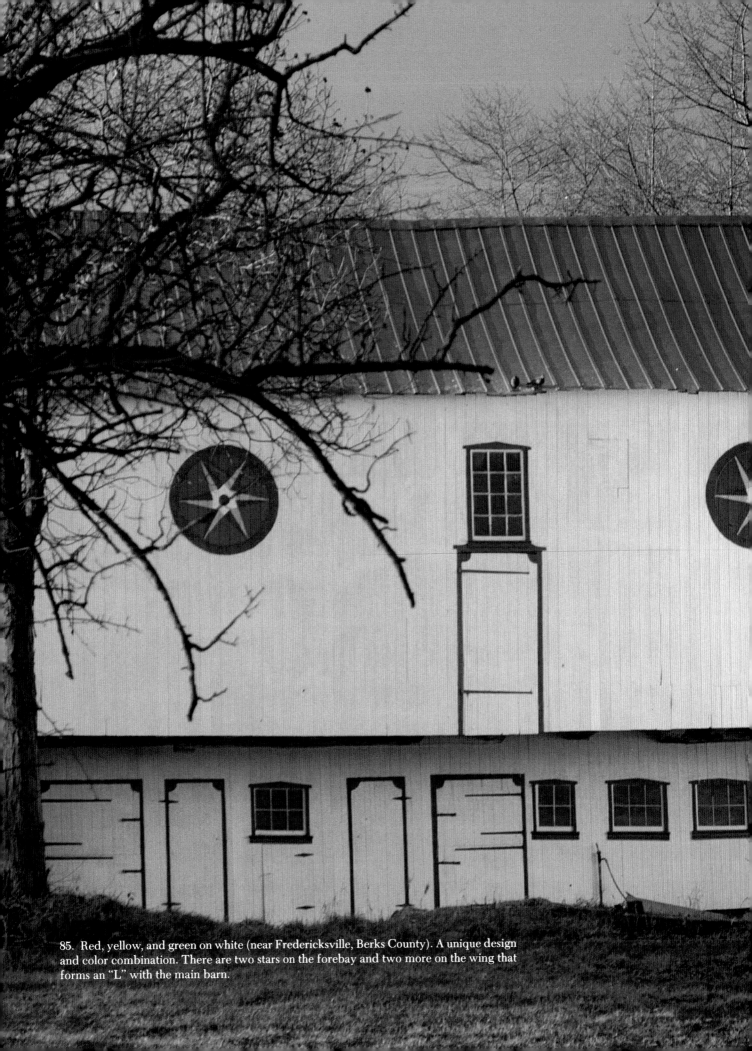

85. Red, yellow, and green on white (near Fredericksville, Berks County). A unique design and color combination. There are two stars on the forebay and two more on the wing that forms an "L" with the main barn.

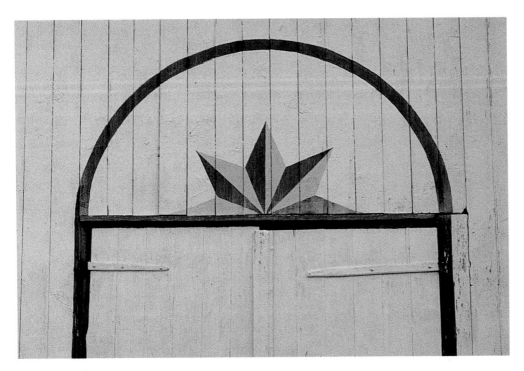

86. Rising sun inside a devil door (near Moselem Springs, Berks County). The star is one half of a whirling Eight-point Star. Instead of having its own border, this star appears inside the arch painted over one of the doors on the forebay of the barn. These arches have been called "Devil Doors" in tourist literature. The Devil is supposed to believe that the arch is part of the door, which is also outlined in paint. Thinking that the door is larger than it really is, he bangs his head on the arch when he tries to enter.

87. Witch foot (Bally, Berks County). "Witch foot" is a direct translation of "hexafoos," the term applied to hex signs by Wallace Nutting in *Pennsylvania Beautiful*. With time, a witch foot was transformed into an arch or decoration painted under the window on a barn. According to tourist literature, the witch foot served the same purpose as the "Devil Door." The witch was supposed to trip on this downward pointing arch when she tried to enter through the window. This particular Witch Foot is made from a section of a Wheel-of-Fortune.

88. Decorated silo (near Upper Bern, Berks County). Very few silos have decorations painted on them. This silo, one of a trio of decorated silos on this farm, has a four-petaled Rosette. This motif, while found in other genres of Pennsylvania German folk art, is uncommon on barns. Also uncommon is the use of Five-point Stars between the petals.

89. Decorated privy (Berks County). This outhouse on the Keim homestead near Lobachsville has been decorated with a Rosette.

90. Is it a barn or is it a church? (Dauphin County). Every building on this Middletown farm has the same Gothic and star-shaped ventilators.

91. In many parts of Pennsylvania, red barns are giving way to white. In Centre County, blue-gray is becoming popular. This barn has a borderless Five-point Star on its gable end. The four white "windows" at the left side of the forebay are painted in for symmetry.

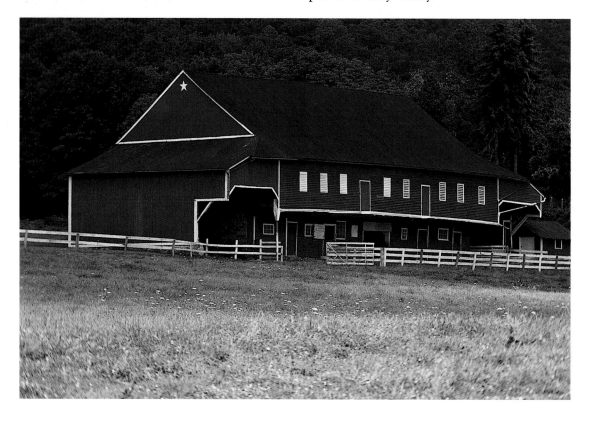

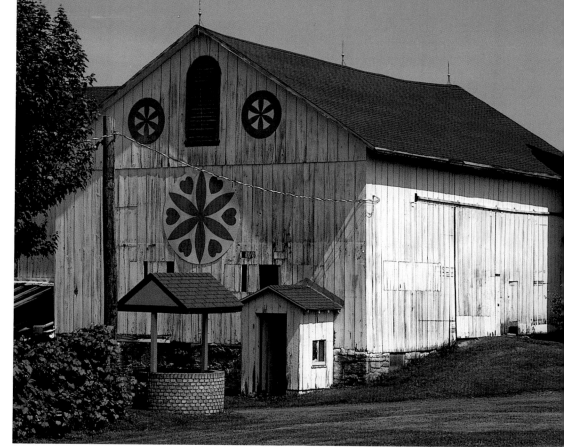

92. The world's largest hex sign? (near Trevorton, Northumberland County). Northumberland County, to the northwest of Schuylkill County, is outside of the central hex-sign region. The Rosettes on either side of the louver are modern adaptations, but they are at least traditionally sized and placed. The large Rosette with hearts must be one of the largest disk signs we have ever seen.

93. Hexapod Swirling Swastika (near Klecknersville, Northampton County). The only extant barn we know of with a six-rayed Swastika, which photographic evidence suggests was once more common.

94. Mosaic hex sign (Lehigh County). This is one of a pair of Rosettes gracing the front of the Parkland Elementary School in Fogelsville. As schools are not related to the tourist trade, these hex signs serve to reinforce local pride.

95. Five-rayed Swirling Swastika (Berks County). Swirling Swastikas with more than four rays or petals are unusual today, although photographic evidence suggests they were once more popular. When the hex sign has more than four rays, it is common to place Five-point Stars in them. This particular example was painted on the front of a grocery store in Bernville.

96. Contemporary disk signs (near Stine's Corner, Lehigh County). Once hex signs began to be painted on disks, painters began to experiment with designs and colors. Although nongeometrical designs with Trees-of-Life and Distelfinks have generally not been accepted by farmers, some adaptations of geometrical designs, such as these, are now finding favor. This barn has only geometrical designs, but the shed, a less important building, has one of the new motifs with a star, two distelfinks, and "Wilkum."

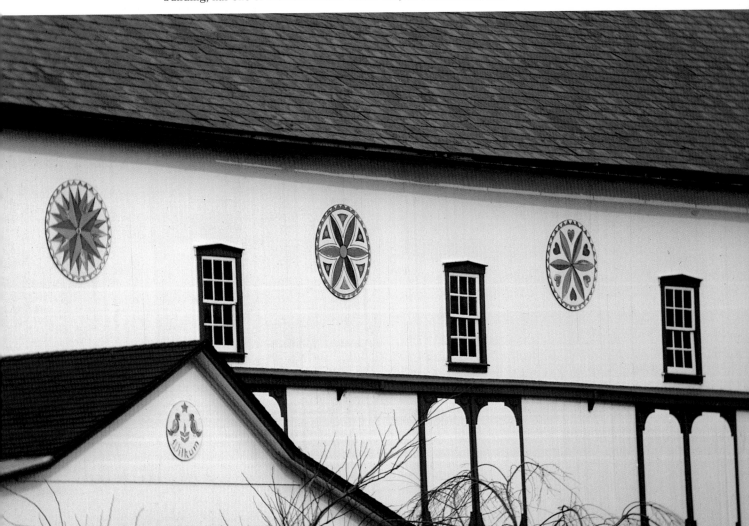

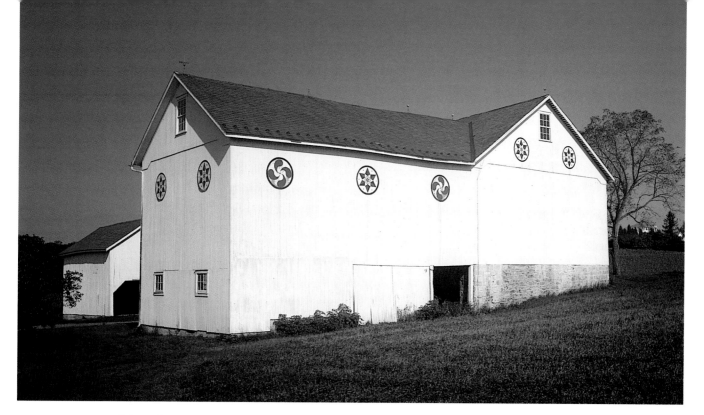

97. Early disk signs (near Pleasant Corners, Lehigh County). This barn has hex signs with traditional designs in traditional locations. However, these hex signs are painted on disks, not on the barn. The Pennsylvania Dutch farmer has used the newer form of hex sign, which is a less expensive form of barn decoration, while keeping those elements that are important: design and placement.

98. Stoney Acres (Lenhartsville, Berks County). A traditional hex sign with a farm-name sign using more modern Pennsylvania German decoration. The Eight-point Star has narrower rays and a smaller central circle than is often seen.

99. Contemporary Five-point Star (near Stine's Corner, Lehigh County). While this star is painted on the barn, it uses one of the more modern designs that has a "tilted" Five-point Star in the middle and hearts between the rays.

100. Modernized star (near Krumsville, Berks County). This sign, one of a matched pair on a small barn, is a modern adaptation of the Eight-point Star. The modernity of the design is shown by the hearts—here doubled—between the rays, the central Rosette with eight petals, and the colors. This sign was signed and dated by Daryl Smith in 1977.

101. The Roy R. Snyder barn (Albany Township, Berks County). This barn uses paired murals instead of hex signs. Murals are normally located in the same places where hex signs appear. In fact, some murals, both round and rectangular, have been painted over earlier hex signs. The score marks and the effects of weathering can sometimes be detected under the newer murals.

102. Wayne L. Weisner farm (near Albany, Berks County). This barn has it all: the farm name and date (1888), American flags, Eight-point Stars with a central wheel, dots between the rays, a scalloped border, and murals with cows and horses (or mules).

103. Eight-point Stars and a rooster (near Pleasant Corners, Lehigh County). While the star on the shed is quite common, even though the color is not, the Eight-point Stars on the forebay are most unusual. In the center of the forebay is a variation of the round mural with a rooster instead of a cow or a horse.

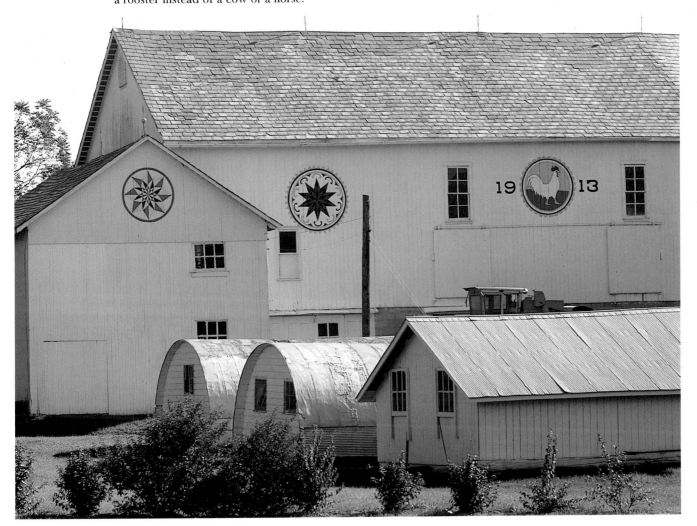

104. Round mural (near Bechtelsville, Berks County). Round murals are common around Boyertown, many of them painted by the same artist. Often they are paired, one picturing a horse and the other, as illustrated here, picturing a cow.

105. Hunsicker's mural (near Albany, Berks County). While round murals seem to be confined to part of the hex-sign region in Pennsylvania, the rectangular mural is found in several parts of the United States. The appearance of this type of mural in widely separated sections of the country may be a matter of independent invention. This particular mural, painted in 1973, brings the farm into the twentieth century with the depiction of the airplane as well as the horse, barn, and windmill.

106. Pennsylvania German Eastlake. This Friedensburg, Schuylkill County, house is bedecked with Pennsylvania German motifs. In addition to the Eight-point Stars and tulips on the porch, shown here, each window has a Rosette over it.

107. Gingerbread hex sign (Klecknersville, Northampton County). Decorative trim was applied to domestic buildings in both the United States and Europe throughout the second half of the nineteenth century. In the Pennsylvania Dutch regions, this decoration was modified to include Pennsylvania German motifs.

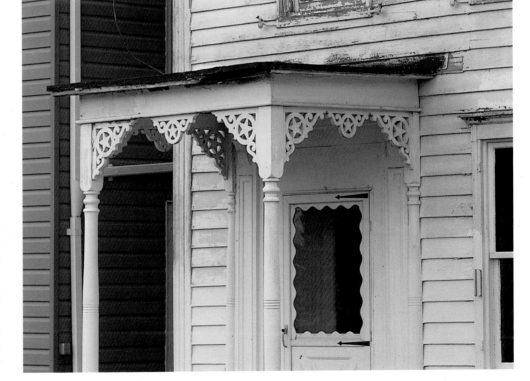

108. Gable-end vents (near Summit Station, Schuylkill County). Decorative vents were often cut into the upper sections of the gable ends of barns. As can be seen in this illustration, their purpose was both aesthetic and functional, for the siding was put on loose enough to permit proper ventilation even without the cut-out vents.

109. *Pennsylvania Roots* (1958). An early work on Pennsylvania German themes by former Greek icon-painter Constantine Kermes. Like the tourist literature, this painting combines the Lancaster County Amishman with the Berks County hex-sign barn. (Roughwood Collection)

110. Hotel restaurant sign (Berks County). Haag's, one of the earliest local restaurants to become known nationally, here uses a hex sign to confirm its self-image.

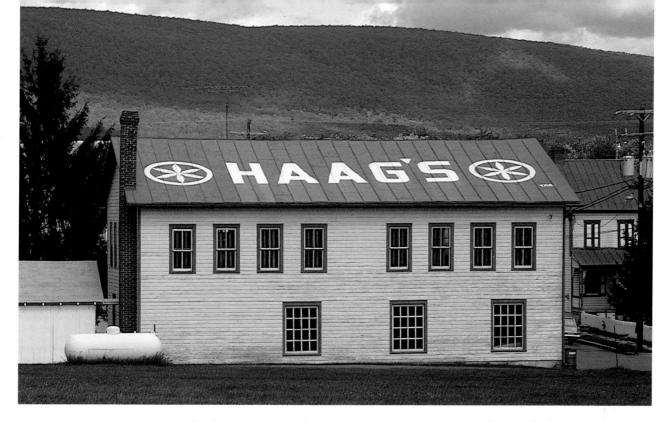

111. Drop-on-in (Berks County). For the Lear-jet crowd, Haag's Hotel in Shartlesville has decorated its roof.

112. Shartlesville Hotel (Berks County). This hotel combines Pennsylvania Dutch "family-style" meals with gifts and crafts aimed at the tourist.

113. Restaurant placemat (Lancaster County). Zinn's Diner on Route 222, which opened its doors in 1951, combines in its advertising the Amish and hex-sign themes. (Roughwood Collection)

114. Soudersburg's Dutch Haven (Lancaster County). Opening in the early 1950s, this restaurant and gift shop mixes Holland Dutch windmills, the Amish, and hex signs.

115. The cover of *The New Yorker* for April 3, 1954. Cover painting by Ilonka Karasz © 1954, 1982, The New Yorker Magazine, Inc. (Roughwood Collection)

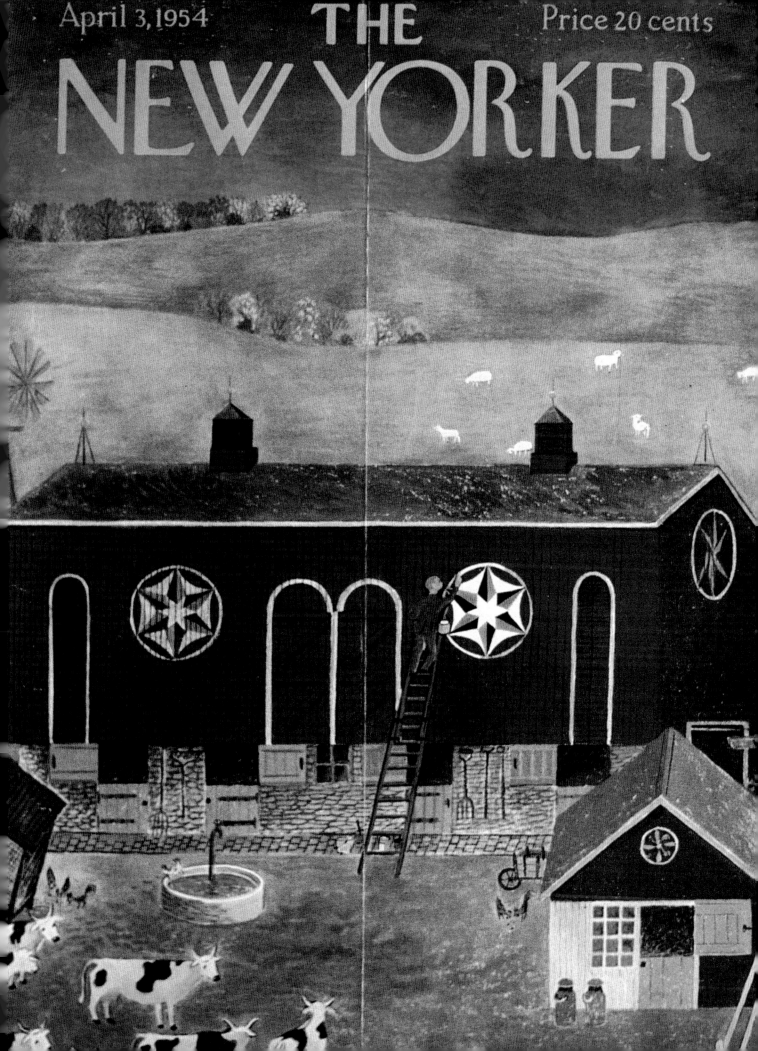

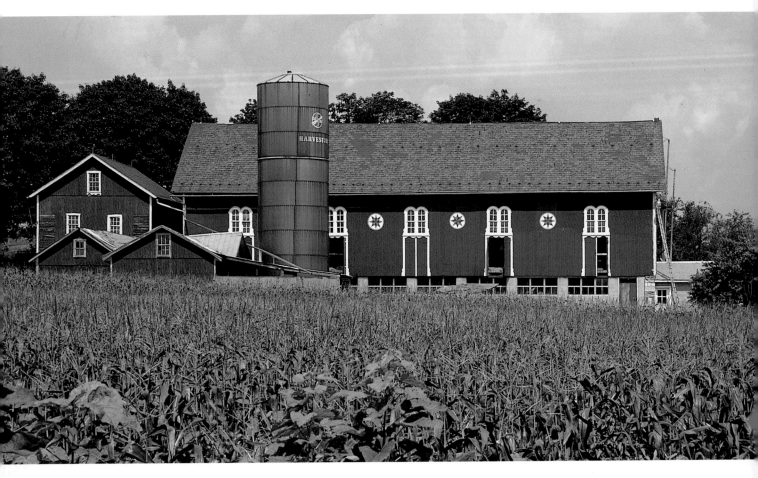

116. These stars create a harmonious balance with the painted trim on this eastern Lebanon County barn.

117. And the tradition continues. Johnny Claypoole working on one of the barns he decorated during the 1985 season.

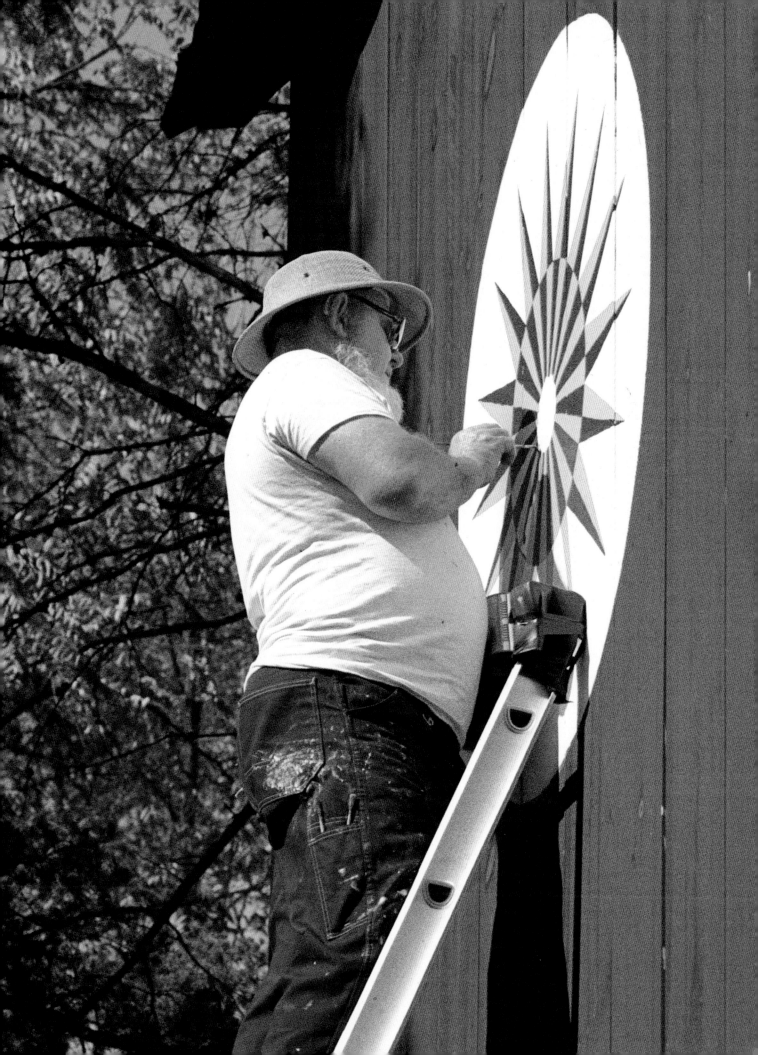